IMAGES
of America

FORT COLLINS
THE MILLER PHOTOGRAPHS

IMAGES
of America

FORT COLLINS
THE MILLER PHOTOGRAPHS

Barbara Fleming and Malcolm McNeill

ARCADIA
PUBLISHING

Published by Arcadia Publishing
Charleston, South Carolina

Printed in the United States of America

Library of Congress Catalog Card Number: 2008934519

For all general information contact Arcadia Publishing at:
Telephone 843-853-2070
Fax 843-853-0044
E-mail sales@arcadiapublishing.com
For customer service and orders:
Toll-Free 1-888-313-2665

Visit us on the Internet at www.arcadiapublishing.com

*We dedicate this book to the collectors and preservers of history
who make the research for books like this possible.*

CONTENTS

ACKNOWLEDGMENTS

Although Malcolm McNeill's collection of Mark Miller real-photo postcards was the genesis for this book, it would not have happened without the cooperation and support of Miller's son John, who provided extensive biographical material and family pictures; of Miller's daughter, Beth Miller Schieck, who shared her memories and family album with us; and most of all of Lesley Drayton, archivist at the Fort Collins Museum, whose willingness to answer questions, dig out negatives, check for accuracy, and allow us access to archival materials was outstanding. The late Stanley Case's book, *Poudre Canyon: A Photo History*, provided a wealth of material about the canyon he so loved.

We also offer heartfelt thanks to Lesley's assistants, Pat Walker and Susan Harness; to retired local archivist Rheba Massey; and to Wayne Sundberg. Pat and Sue cheerfully located information for us whenever we asked for it. Rheba, a treasure trove of information about archival materials, as well as Lesley Drayton, helped us ensure historical accuracy. Wayne provided some of the book's images. Our spouses, Gail McNeill and Tom Fleming, were helpful and uncomplaining throughout the process of creating a book, which can be time-consuming and, occasionally, stressful.

It is said it takes a village to raise a child; the same can be said of a book. It takes a whole collection of friends, colleagues, and family to see it through from the moment the idea is born to the day the manuscript goes to the publisher. We are deeply grateful for our village.

The images in this volume appear courtesy of the Fort Collins Museum Local History Archive (FCM), John C. Miller (JCM), Wayne C. Sundberg (WCS), and Malcolm E. McNeill (MEM). The images from the Fort Collins Museum also include an image number that should be used when making inquiries.

INTRODUCTION

Mark Miller's lifelong love affair with photography, with his adopted town of Fort Collins, and with nearby Poudre Canyon created a legacy of more than 70,000 images. From the time he began to work as a photographic apprentice to Claude Patrick in 1910, to when he opened his Fort Collins studio in 1914, to the end of his life decades later, he chronicled the people, places, and events of this evolving high-plains town with his cameras. While most of his photography was commercial, he also captured special family moments and breathtaking canyon landscapes on film.

Fort Collins: The Miller Photographs brings readers some of the best of Mark Miller's images. The photographs in this book offer samplings of the commercial and personal pictures Miller took during his working life; collectively, they stitch together a patchwork quilt of the past, the time during which this gifted photographer lived and worked.

We begin with a brief look at Mark Miller's life using some of his family photographs. Not only do these photographs illustrate Miller's life, but they also offer a glimpse of small-town family life in the early part of the last century. All four Miller children were involved in the business in some way, and Miller's wife, Effie, an artist in her own right, often hand-tinted his studio portraits to give them a special touch. Perhaps the Miller Studio might have been called the Miller Family Studio.

When the young couple set up shop in Fort Collins, the population was around 8,000. By the time Miller died, it had grown almost six-fold. Miller's photographs reflect many of the changes the college town went through over five decades. In the years of the 19th century, agriculture was the mainstay of the town, which had begun life during the Civil War as a small military post. The land grant agricultural college was a natural outgrowth of the area's economy, which was focused on crops such as wheat, corn, beans, and oats and sheep and cattle ranching. It welcomed its first students in 1879. By the dawn of the 20th century, the faculty and the student body were growing quickly.

Gradually, as more settlers came to the area, farming and ranching gave way to other industries and interests. The college expanded its mission, broadening curricula in the humanities and sciences, and becoming a premier research institution, as well as fostering a nationally recognized school of veterinary medicine. After World War II, veterans came to town by the hundreds, attending college on the GI Bill. Many stayed; their presence influenced both the college and the town. By the 1950s, Colorado State College of Agricultural and Mechanic Arts had become Colorado State University. (Since the college's name changed several times during the period this book covers, in the text it is referred to as simply the college.) Today Fort Collins is a city of about 130,000 residents, still a "college town" but no longer a "cow town," and the university enrolls more than 25,000 students each year.

But not everything changed. Despite numerous upgrades and alterations, downtown Fort Collins appears much the same as it did when Miller first arrived. Some of the buildings are gone; all have different tenants, but its unique character has been preserved. Encompassing Old Town Square, a stretch of College Avenue and a few side streets, the downtown was used as a model for a similar structure in Disneyland.

Miller had a special love for nearby Poudre Canyon, where Fort Collins residents went to hike, fish, and camp. He took many photographs of the landscape—when the light was right—and the colorful resorts that dotted the canyon. With his family, he often made summer excursions up the canyon, placing his real-photo postcards in the resorts and collecting his profit (2¢) for every one that sold.

Miller bought a working studio. Some of the early photographs in the negative files may have been taken by Miller's predecessors. Some of the later photographs may have been taken by his youngest son, John Miller, who also became a photographer. Unfortunately, no record was kept of the specific photographer, and we are forced to treat them all as Mark D. Miller's photographs. A few photographs used in the book were not taken by Miller. They are marked accordingly.

The first half of the 20th century was, for many Americans, a time when families were close-knit, like Miller's, when mom-and-pop businesses thrived, when pleasures were homespun and inexpensive. Mark Miller's photographs evoke that idyllic time in the enduring images of the town he embraced as his own, the canyon where Fort Collins played, and his much-loved family. We invite you to come with us to Fort Collins, Colorado, between 1910 and 1970, through the lens of Mark D. Miller.

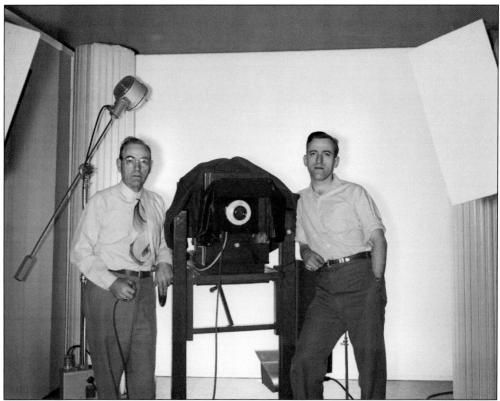

In the early 1950s, Mark Miller (left) made this portrait of himself and his son John, who worked with him in Fort Collins for a time. In 1955, following in his father's footsteps, John opened his own photography studio in New Holland, Pennsylvania. Mark Miller made most of the photographs used in this book, and John Miller provided technical insights on his father's craft. (FCM.)

One

MEET MARK MILLER

Mark Miller was 13 when his parents, Amos and Mary Miller, moved to Fort Collins in 1905. Amos, an investor and farmer, may have chosen the high-plains town because of his wife's asthma. Whatever the reason, the decision was life-changing for Mark.

Mary Miller waited in Denver with Mark, his older sister, Emma, and his younger sister, Geneva, while Amos sought a location for a hardware store—at least, that's how the family story went, though accounts differ as to whether Amos opened a store. He had been in the hardware business in Scranton, Kansas, where the family hailed from originally.

For a short time, the family lived in Ault, east of Fort Collins, before making the permanent move to Fort Collins. The small Western town they chose for their new home was neatly laid out with wide streets, abundant trees, and many large, sturdy houses. The Miller family had their choice among many churches. In the late 1890s, Fort Collins had banned the sale of alcohol, which tended to attract family-oriented, hardworking residents.

Dominating the eastern horizon was the Great Western Sugar Company factory, a major employer that processed sugar beets. Few cars traversed the unpaved streets. A well-used train track intersected the town on Mason Street. The student body at the college infused the town with a lively, youthful air.

Only four years after their arrival, tragedy struck the Miller family when Mark's bright, popular, older sister, Emma, who had been going to college in Boulder, Colorado, was stricken with appendicitis. Despite doctors' best efforts, she died of complications from surgery and infection, and, says Mark's daughter, Beth Schieck, "the family was never the same again."

Mark, a year younger than his sister, attended public school for a while, but boys his age were expected to make their way in the world. He began to work part-time as an apprentice to a bicycle repairman.

A short time later, his life took a fateful turn when he met H. C. Bradley and Claude Patrick.

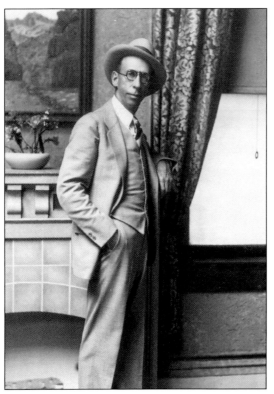

Miller could not have found better mentors than Harry C. Bradley (left) and Claude Patrick (below). Photographer Harry C. Bradley came to Fort Collins in 1899, setting up shop on North College Avenue and using poetry and bold advertising to bring in customers. He soon moved to South College Avenue and built the studio Miller later bought. Around 1908, Bradley fell in love with cars, brought in Patrick to help with his photography business, and became one of the first car dealers in town. Miller, working after school at the fix-it shop near the Bradley Studio, met Bradley and Patrick, and got interested in photography. In 1911, with Bradley selling cars, Patrick bought the studio, taking on Miller as his assistant. Miller never looked back. Patrick, Bradley, and Miller remained lifelong friends. (Left, FCM M06193; below, FCM M00668.)

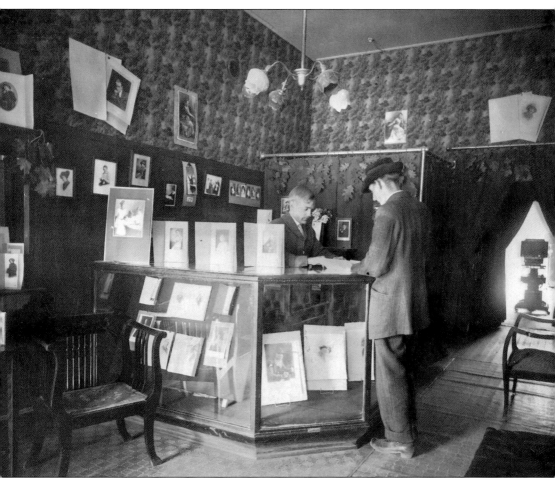

In mid-1912, Miller opened his own business in Longmont, about 40 miles southwest of Fort Collins. In the early 20th century, photographers often set up their studios in their homes. Miller's was probably in his home, the most feasible way for him to make a living taking pictures—the only career that held any interest for him. Miller's children John and Beth are unsure how their father financed the studio, which he apparently purchased; he may have gotten a loan or gift from his father, Amos Miller, who always seemed to have money, according to Beth. As Miller helps a customer in his studio, his large studio camera is visible at right, set up in the room with the best light. His photographs—mostly portraits, his bread and butter—decorate the outer room. (JCM.)

New Year's Eve in 1913 was a special day for Mark Miller and his bride, Effie Hall. They met at the First Methodist Episcopal Church in Longmont, but soon afterward, Effie left her job at a store called Noah's Ark to move to her brother James's farm near Berthoud because of his severe asthma. Mark rode his bicycle 15 miles to James's farm to court her. The photograph at left shows Effie in her wedding clothes. The caption called them her wedding "trigs," an old word meaning "sharp" or "neat." The photograph below is part of a series showing the happy couple in their first home. (Both, JCM.)

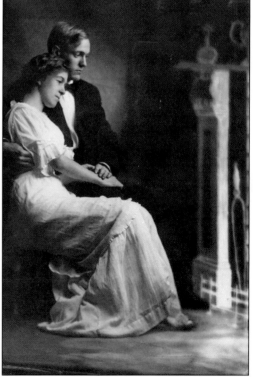

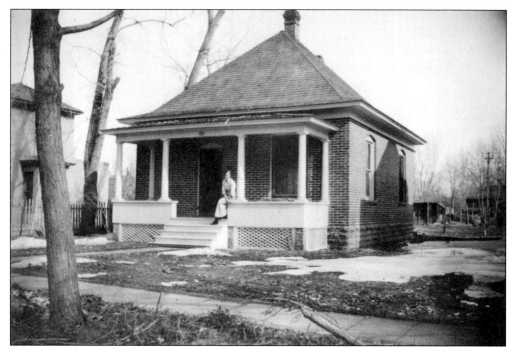

Effie perches on the porch of the Longmont house at 438 Collyer Street. Though there is a sidewalk in front of the house, it is likely the streets were unpaved. A shed at the back of the property may have held chickens; many town dwellers kept chickens and sometimes ducks, goats, or pigs. (JCM.)

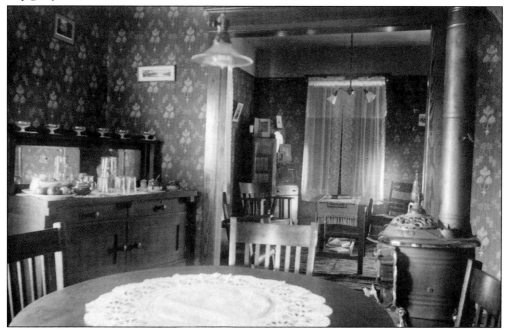

From the flowered wallpaper to the lace tablecloth, the inside of the couple's first home typifies the early 1900s. Lace curtains hang over the window; rocking chairs in the sitting room await their occupants. The wood stove visible in the photograph probably heats the whole house. (JCM.)

This building at 146 South College Avenue housed the Bradley studio. Bradley first rented a lot on North College Avenue from pioneer settler Abner Loomis. When Loomis died in 1904, Bradley moved his studio to South College Avenue and eventually built at the 146 site. In 1914, the upstairs became Miller's studio and the couple's first Fort Collins home. (FCM H06193.)

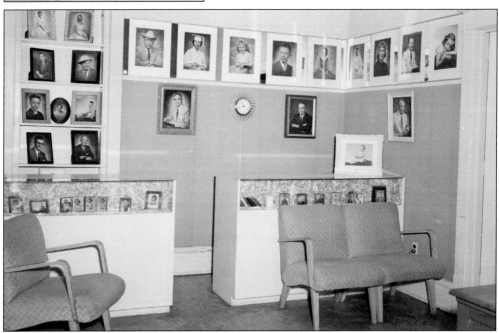

Back home in Fort Collins, Mark and Effie worked together to make their mom-and-pop business, so typical of the times, a success. This front counter was Effie's station during busy periods. The display of portraits on the walls advertises the nature and quality of Miller's work, neatly and artfully arranged. (FCM H09466.)

Miller loved big negatives and large-format cameras for the detail he could capture on the film and for the control he had over his image. Hundreds of his 8-by-10-inch negatives, some taken with the camera in this photograph, still exist, showcasing Fort Collins and the skill and artistry he brought to his craft. (JCM.)

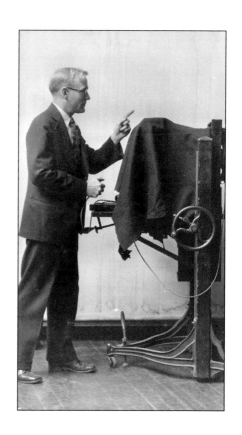

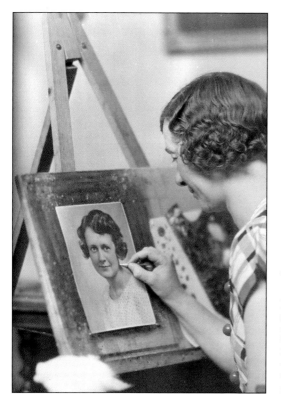

Mark Miller started working well before color film was introduced by Kodak in the 1930s. If a customer wanted a color portrait, Effie Miller used her artistic skill to hand-color the black-and-white photograph with transparent oil paints. Here she is at work on a portrait. The Fort Collins Museum has a number of examples of her hand-colored portraits in its collection. (FCM M01973.)

After a short time in the apartment, the Millers moved to 315 Whedbee Street, where they lived for the rest of their lives together. Happily, the house was only two doors away from the Amos Miller home, making it easy for Grandmother (Mary) Miller to mind the children while Effie worked. When they were old enough, Keith, Warner, John, and Beth helped out at the studio. (JCM.)

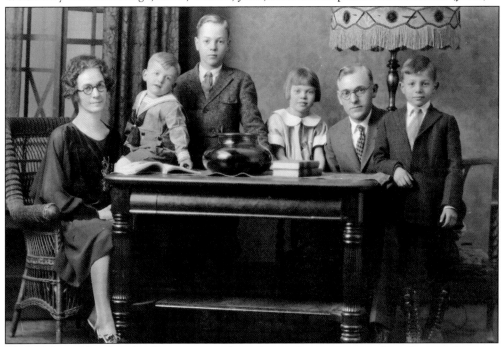

Mark Miller seldom let a family occasion go by without taking a picture, often allowing dinner to cool while he adjusted his camera. (The family always ate dinner together.) Sometimes they sat for more formal portraits to use as Christmas cards. Seated here for such an occasion are, from left to right, Effie, John, Warner, Beth, Mark, and Keith, probably about 1925. (JCM.)

When Miller started taking photographs, it was not an easy job. The cameras were large and cumbersome. The view camera, developed in the mid-1800s, featured a flexible bellows and a piece of glass on which the image is projected upside down. Miller also carried a selection of lenses. Inside, he used flash powder and once came close to being blinded when Effie accidentally tripped the trigger. (JCM.)

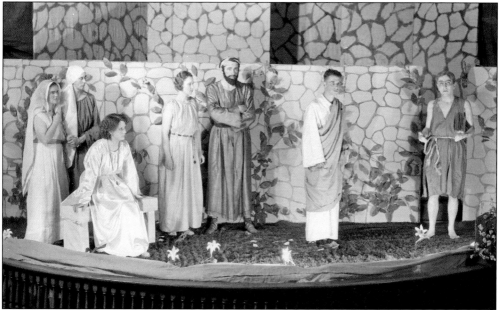

Homegrown pleasures like amateur dramatics offered a break from long work hours. Here Effie and Mark perform in a play, *Simon the Leper*, at the First Methodist-Episcopal Church in 1935. Along with reading and art, Effie was active in the church's Foreign Missionary Society. Both enjoyed bridge, a popular pastime of the day, and Mark loved gardening and fly-fishing in the Poudre River. (FCM H17915.)

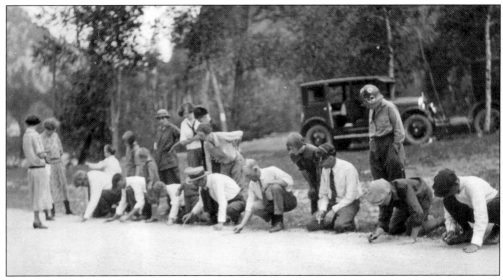

Miller's son John says the three local photographers in Fort Collins were not rivals but associates who helped each other with supplies, shared the taking of school photographs, and often met to discuss techniques and technology. The Northern Colorado Photographers' Association had an annual mountain picnic. Just what they are doing here is lost in the mists of history. Miller (hatless) squats, center, with Effie to his right. (JCM.)

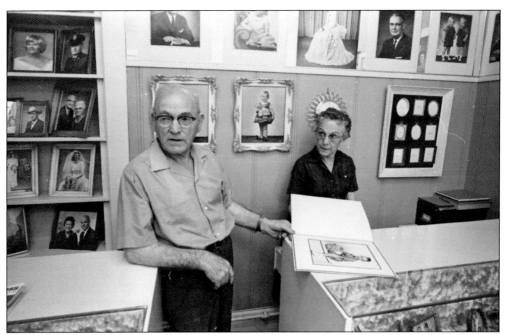

A newspaper photograph shows the Millers late in life. In 1970, Mark Miller had a heart attack while carrying his large-format camera upstairs to his studio. He died a few months later. Effie Miller lived four more years but sold the studio. Miller's nearly 60 years' work created a lasting legacy for Fort Collins, a treasure archived and catalogued at the Fort Collins Museum. (FCM C01333.)

Two

AROUND THE TOWN

Miller's chosen town was bounded, more or less, by Prospect Road to the south, Laporte Avenue to the north, Shields Street and City Park to the west, and Hospital Road (now Lemay Avenue) to the east. During most of his career, Fort Collins was a quiet Front Range town, until the return of the World War II veterans started a period of explosive growth that would last to the end of Miller's life and beyond. The tenor of the town remained conservative, with Prohibition in effect until 1969. Farms, orchards, and sheep ranches ringed the town. It was a safe, happy place to raise children.

Lining the streets of College Avenue and the area known today as Old Town Square—framed by Linden and Jefferson Streets and Mountain Avenue—was a colorful collection of locally owned establishments: shoe stores, bakeries, billiard halls, restaurants, and sundry other businesses, along with hotels and movie theaters, offering just about everything a family might want to buy or do. To lure shoppers, retailers often hired photographers to photograph their storefront displays for advertisements.

Within walking distance from most homes was a wide choice of churches, with the spire of St. Joseph's Catholic Church on West Mountain Avenue dominating the downtown skyline. Elementary schools, too, were nearby, but Fort Collins High School, built in 1925 on Remington Street, was considered far from town. What had been the high school, on Meldrum Street, became Lincoln Junior High School. During much of Miller's time, the physical campus and college enrollment remained small. Every neighborhood had at least one small, family-owned grocery store.

Crime did occasionally happen in the mostly quiet town; Miller was sometimes called on to photograph the scene. Some local citizens, too, were busy finding ways to circumvent the ban on liquor.

As the town grew, downtown began to lose its central retail role, gradually evolving into the entertainment and arts district that characterizes it today.

Much has changed since Mark Miller aimed his camera around the town he had chosen as his home. Much, too, has remained the same.

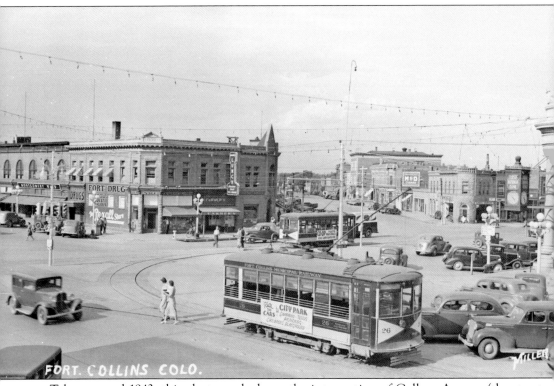

Taken around 1943, this photograph shows the intersection of College Avenue (the street Trolley 26 is on) and Mountain Avenue, with Linden Street visible at its junction with Mountain Avenue. The photograph shows the wide streets, historic buildings, and trolley system that made Fort Collins so popular with visitors and this intersection so popular with photographers. The Avery Block, with Fort Drug and Montgomery Ward, is one of the most historically and architecturally significant buildings in Fort Collins. It was designed by Montezuma Fuller, a prominent Fort Collins architect, to anchor downtown at this major intersection. Unfortunately, two other buildings shown here did not fare as well. The First National Bank was demolished in 1961, replaced with a more modern but less stately building, and the Wells Fargo Express Building on the northeast corner of Linden Street and Mountain Avenue was torn down, replaced with Chuck's Phillips 66 Station. (FCM H02746.)

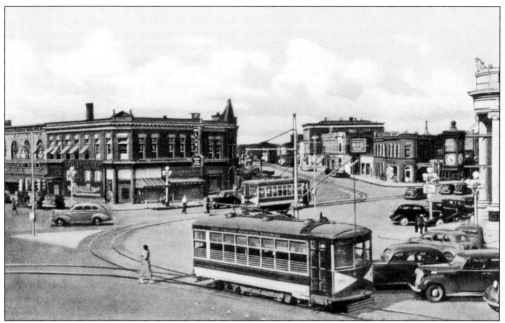

Miller told his son John that some of his photographs had been used without permission to make printed postcards, as this postcard, a copy of the Miller image shown on the preceding page (with minor changes), exemplifies. Printed in high volumes, it, rather than Miller's real-photo postcard, has become the more recognized image of downtown Fort Collins. (MEM.)

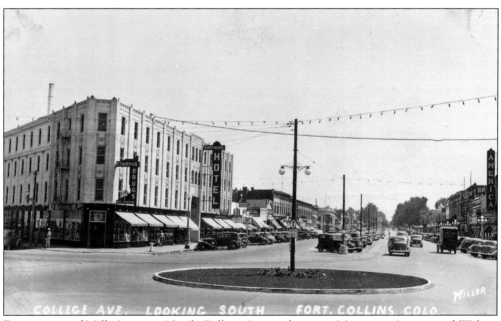

During most of Miller's career, North College Avenue between Mountain Avenue and Walnut Street was the town center. In this photograph, the First National Bank is visible in the center. Today several historic buildings remain, including the Northern Hotel and the Trimble, Welch, and Opera Blocks. (A "block" is a building or buildings with the builder's name, rather than all the buildings from intersection to intersection.) (MEM.)

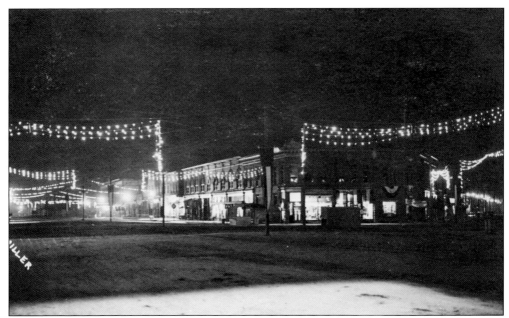

This night scene was photographed in July 1914, when Fort Collins was 50 years old. The three-day semi-centennial celebration was underway with daily parades, barbecues, fireworks, and parachute drops by the "Human Blackbird." Street decorations were not forgotten; L. W. Cody, manager of Northern Colorado Power, promised "the most beautiful illumination ever seen here," lighting up the College Avenue–Mountain Avenue intersection. (MEM.)

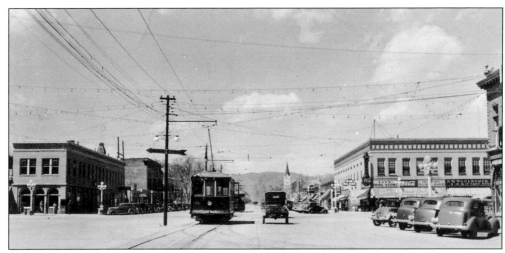

Fort Collins considered itself thoroughly modern when the trolley arrived. The first electric cars, rather cumbersome Woebers, began operating in 1907. By 1921, smaller Birney cars (called "galloping geese" by locals) replaced the Woebers and operated for 40 more years, the fare still one nickel. (MEM.)

The home of Eleanor "Nellie" Landbloom, 116 Pearl Street, was near the trolley line. So familiar was she to conductors, the story goes, that they would clang the bell as they approached her stop. Along with others, she fought a fierce but losing battle in the 1950s to prevent discontinuation of the long unprofitable system. (FCM M11564.)

After trolley service was discontinued in 1951, a group of dedicated trolley fans sought to preserve whatever they could. Here they gather at the trolley barn, 330 North Howes Street, salvaging trolley memorabilia. After sitting neglected on the Fort Collins Museum grounds for years, Car 21 was restored and makes regular short runs every summer; at this writing, Car 25 has just returned to Fort Collins for restoration. (FCM M08467.)

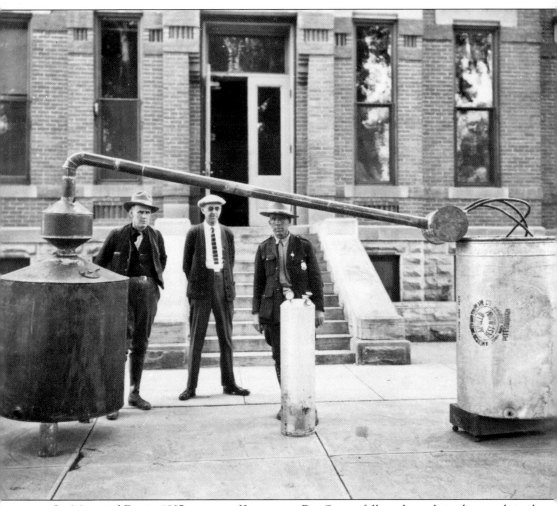

On Memorial Day in 1927, a group of Longmont Boy Scouts followed a path in the woods in the St. Vrain Canyon area. They discovered a camouflaged tent covering the largest still ever found in Larimer County. The next day, Sheriff Fred Harris and other law enforcement personnel, tipped off by the Boy Scouts, waited to discover who would appear to work the still. They arrested W. T. Weese, who claimed three men had paid him $10 to feed the horse tied nearby. The 200-gallon copper still, with its condensing coil, four-burner heater, and gas tank, was taken to the road by horseback and trucked into Fort Collins, where Miller took this photograph in front of the sheriff's office in the old West Mountain Avenue courthouse. The officers are (from left to right) Sheriff Harris, Deputy Sheriff Elmer I. Cooke, and county traffic officer Gene Savard. (FCM H02341.)

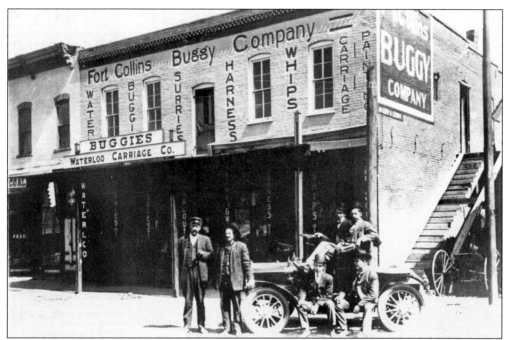

A 1907 advertisement for the Fort Collins Buggy Company at 310 Jefferson Street claimed they sold 436 buggies that year, enough to make a "procession two and one-half miles long." In 1910, the time of this photograph, automobiles were catching on; by October 1916, the newspaper signaled an amazing transition: "last Saturday only two teams were hitched on College Avenue." Automobiles filled the remaining space. (FCM H01522.)

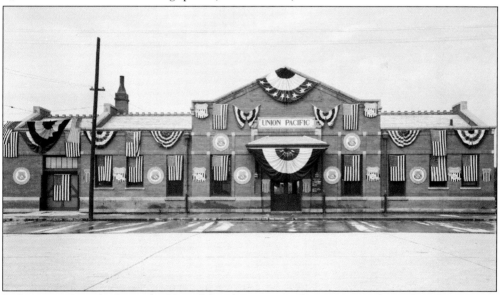

In January 1910, the buggy building (above) was part of a Union Pacific Railroad auction of buildings on land the railroad had bought. Platform wagons carried $10 dollars. Some were moved, others demolished. The Union Pacific Passenger Depot, 200 Jefferson Street, replaced some of the auctioned buildings. Here it is decked out for the 1928 Fourth of July celebration. (FCM H06180.)

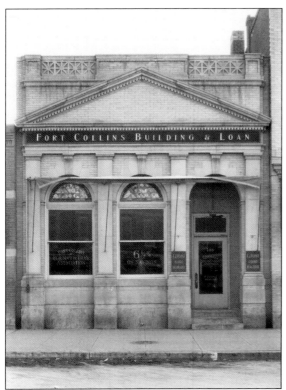

In the early part of the 20th century, building and loan banks allowed thousands of lower-income citizens to own homes at low interest. This classic revival–style building at 146 North College Avenue began in 1907 as the Commercial Bank and Trust, became Fort Collins Building and Loan, and later housed a newspaper office. Today, looking much the same, it is home to a bar called the Vault. (FCM H08812.)

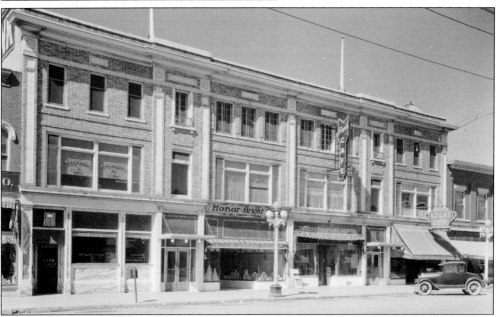

The Opera House, 127 North College Avenue, once hosted lively entertainments. Local leaders Franklin Avery, Jacob Welch, and Jay Bouton hatched the idea of building an opera house to infuse Fort Collins with culture; by 1881, it was in business, featuring such attractions as plays, musicians, acrobats, and phrenologists (hypnotists not allowed). Its heyday ended when motion pictures became popular, but the building still stands, filled with shops. (FCM H06189.)

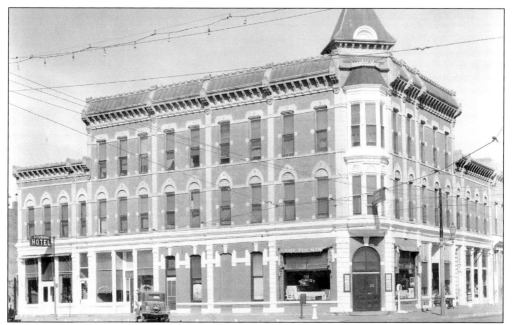

The building at 250 Walnut Street, built in 1882 by partners Abner Loomis and Charles Andrews, began as the first bank in Larimer County. Deteriorating through the decades, the building saw varied uses, including a bar, post office, Masonic Lodge, and hotel. The Linden Hotel building, an architectural jewel of Old Town, was renovated in 1994 through public/private funding and today has both retail and office space. (FCM H06191.)

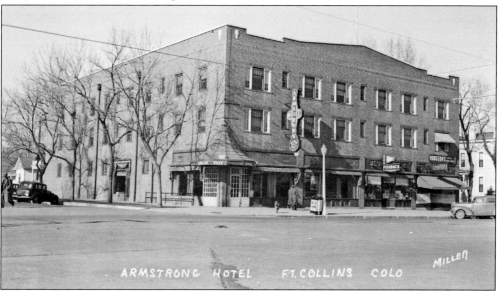

The Armstrong Hotel, 261 South College Avenue, opened in April 1923 and was labeled by the *Fort Collins Courier* as the "largest and most expensive business block ever built in Fort Collins." The hotel housed Fort Collins's first AAA office and, during World War II, served as soldiers' barracks. Falling into disrepair, it closed in 2000, reopening in 2004 after renovation that preserved the curved staircase and pressed-tin ceiling, and re-created the 1940s-style neon sign. (FCM H01963.)

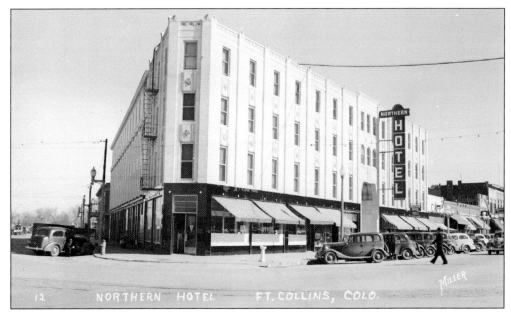

In the 1880s, passengers arriving at the railroad station at Mason Street and Laporte Avenue could walk to nearby Agricultural Hotel, a wooden structure that stood at the corner of College Avenue and Walnut Street until 1877. It then became the Commercial Hotel until 1905, when it was completely renovated and reopened as the Northern Hotel. (FCM H03491.)

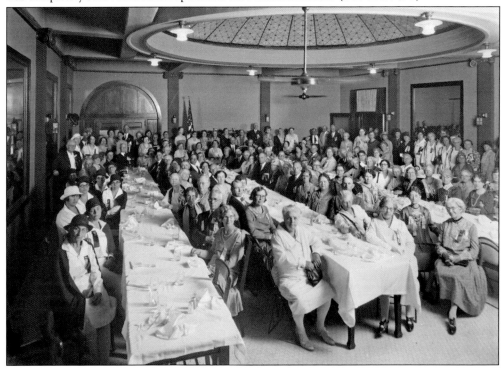

The 1905 renovation expanded the lobby, added stained-glass panels to the ceiling, and added the stained-glass dome, shown in this photograph, to the dining hall. In 1924, a fourth floor was added, and in 1936, the Northern was spruced up with an art deco renovation. (FCM H06169.)

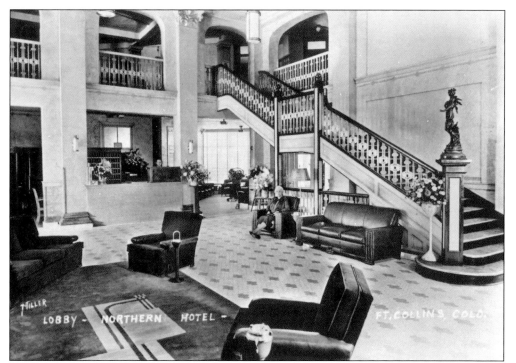

The decline of train traffic hurt the Northern Hotel's business, and the building, once called the "Pearl of Northern Colorado," deteriorated. A bad fire in 1975 led to the closing of the upper floors. In 2001, the Northern Hotel was again renovated and reopened as senior housing. The lobby was returned to the glory shown in these Miller photographs, and the stained-glass dome was cleaned and repaired, piece by piece. The lobby is open to the public, and the dome can be seen by visiting the Mountain Shop on College Avenue. (Above, FCM H08067A; below, FCM H08067C.)

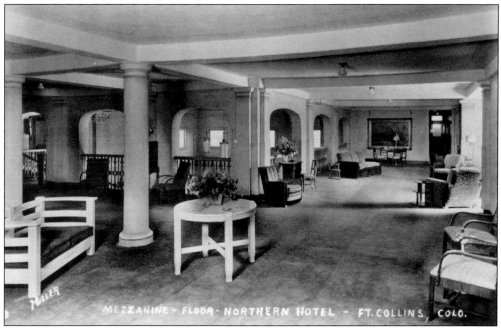

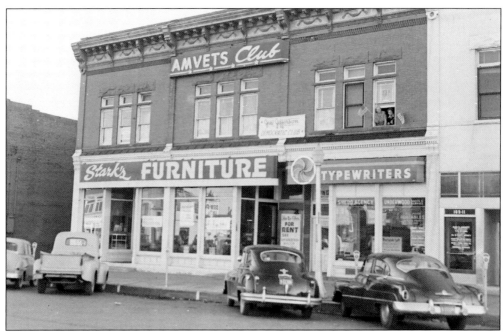

In January 1885, a fire destroyed the original Kissock Block. It was immediately rebuilt. The Odd Fellows Lodge leased the second floor and remained a tenant for 50 years, though by the time this c. 1946 photograph was taken, the Amvets Club had taken its place. The building, located at 117 East Mountain Avenue, is on the National Register of Historic Places. (FCM H09537.)

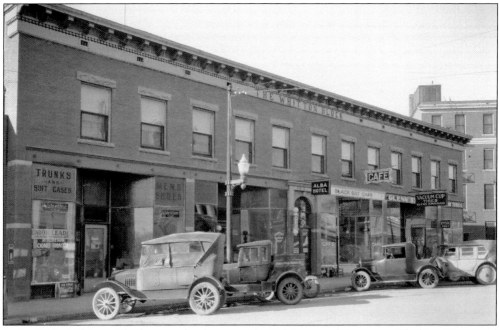

In 1906, the Whitton Block opened as home to the Whitton and Company Clothing Store and other retailers. Several different hotels called the second floor home, including the Alba Hotel, shown in this c. 1928 photograph. Today the building at 223 Walnut Street houses the District One Police Station. (FCM H06185.)

A pogrom in Russia brought Joe Alpert and his family to America; asthma brought him to Colorado. One of the first Jewish immigrants to settle in Fort Collins, he arrived in 1903. Alpert became a successful businessman. Among his many businesses was the Electric Shoe Store that he moved to the Alpert Block, shown here, when it opened in 1916. The Alpert Block is located at 140–142 South College Avenue. (FCM H06193.)

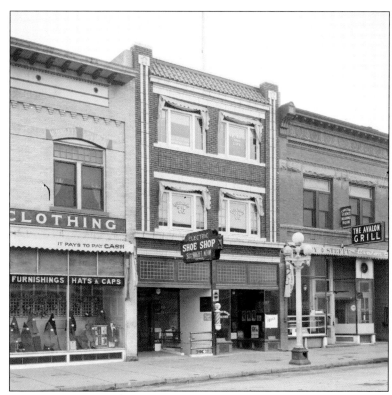

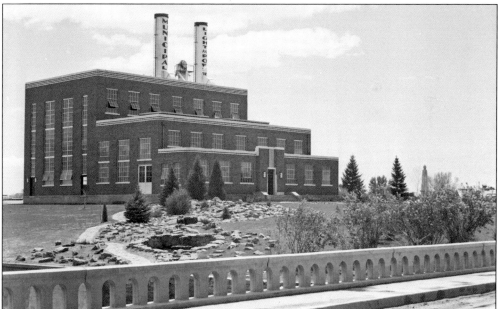

Until 1935, private businessmen supplied electric power in Fort Collins. Public works programs during the Depression brought about a change of heart, leading voters to approve a municipal electric supply after rejecting several previous proposals. Now leased by the college, the power plant at 401 North College Avenue was constructed in 1935 on the site of the city dump after the city won a lengthy court battle with the Public Service Company. (FCM H06179.)

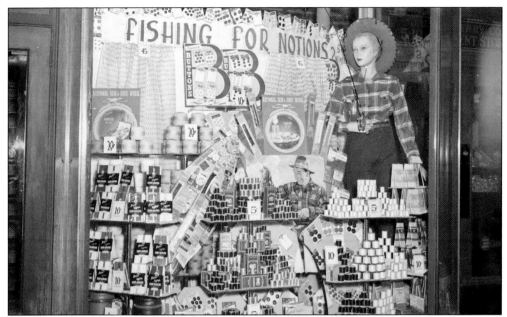

Retailers had various ways of attracting customers; one popular method was a window display such as this one at the J. J. Newberry Store, 115 South College Avenue. A rival to the F. W. Woolworth chain of five-and-dime stores, Newberry's offered Fort Collins residents sundry items, like the thread shown here in this creative display, "Fishing for Notions," for around 20 years. (FCM H08470C.)

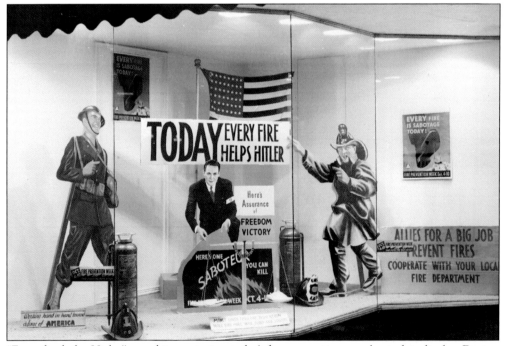

"Every fire helps Hitler" says this patriotic retailer's fire prevention–week window display. During World War II, goods and materials went first to the war effort, requiring careful rationing at home. Note the 48-star flag. (FCM H09402B.)

In the days before television was common, it was easy to draw a crowd for "living window" displays (above). Performers demonstrated tasks or products—a good way to attract customers and entertain them at the same time. Often displays were put up during the holiday season. Mrs. 1909 and Mrs. 1950 demonstrate different methods of ironing in the living window display below. Mrs. 1909 uses an iron probably heated on a stove, as no electric cord is visible, while Mrs. 1950 enjoys the use of a mangle iron, popular at a time when homemakers still ironed linens and draperies. (Above, FCM H18177A; below, FCM H18177C.)

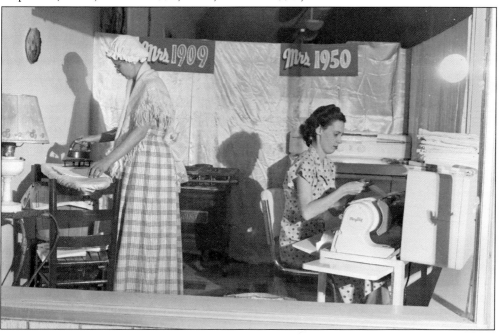

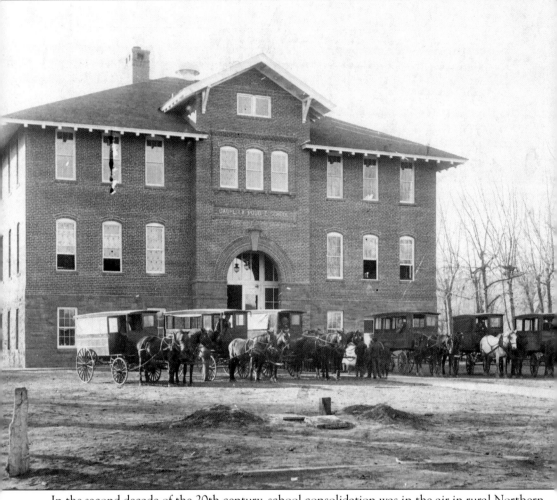

In the second decade of the 20th century, school consolidation was in the air in rural Northern Colorado. Laporte, a few miles northwest of Fort Collins, became a central location for seven rural schools. Officials laid the cornerstone of the Laporte Cache La Poudre District 60 School on July 4, 1913, before a crowd of 300. On October 10, the new school opened with 181 students. Six routes had been established to get students to and from school via six wagons purchased from the Delphi Wagon Company in Indiana. One writer said the wagons "were not unlike the wagons used . . . for conveyance of prisoners from one jail to another." The wagons were fitted with side curtains to protect the students from weather. That same year, during one of the worst winters in Northern Colorado history, wheels were replaced with bobsleds to get the children to school. (FCM H03019.)

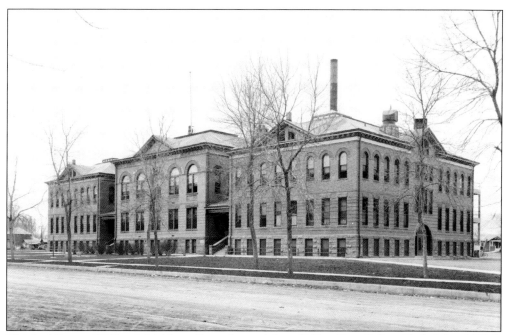

This building at 417 South Meldrum Street began life in 1902 as Fort Collins High School. With the opening of the new high school (below) in 1925, it became Lincoln Junior High School. Hints of the auditorium and gymnasium are all that remain of the junior high school, incorporated into the Lincoln Center for the Performing Arts in 1976. (FCM H08034.)

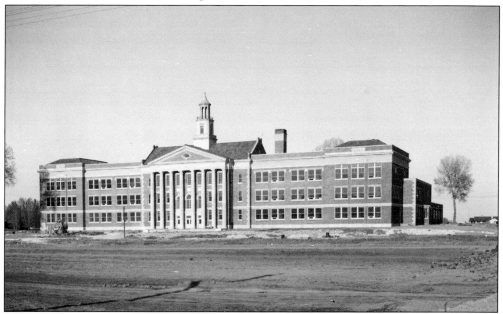

Fort Collins High School, 1410 Remington Street, is a sturdy structure built to withstand earthquakes. The building with its distinctive columns and tower housed all area high school students until Poudre High School was constructed in 1963. Replaced by a new Fort Collins High School at 3400 Lambkin Way, the building now houses the college drama and arts departments. (FCM H06167.)

On May 4, 1931, Miller photographed teachers and students standing in front of Remington School at the southeast corner of Olive and Remington Streets. The school replaced Fort Collins's original "yellow schoolhouse" at 115 Riverside Drive in 1878. The brick building, which cost $6,954, featured a central tower, not visible here, that housed the school bell. The building was razed in 1968. (FCM H09786A.)

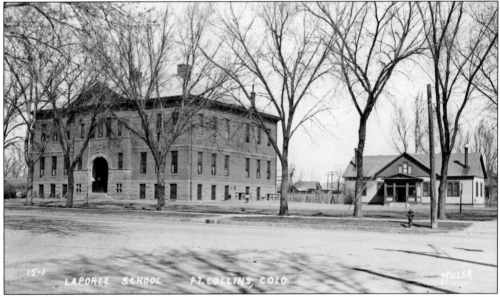

Opening in 1908, Laporte Avenue School was half of the first set of identical-plan elementary schools; the other was Laurel Street School. Though critics decried the practice, the school district saw it as a way to save time and money. When built, Laporte Avenue School was considered "almost out in the country.'" Juan Fullana Elementary School replaced it in 1968. (FCM H01958.)

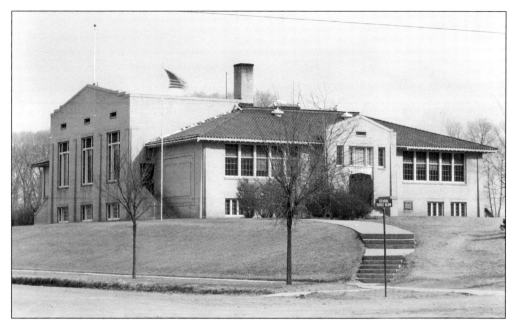

Lincoln and Washington Schools were another set of twin schools. Built in 1919 at 501 East Elizabeth Street, Lincoln School was designed as part of a transformation from morally inspiring structures to efficient machines for education. In 1939, Lincoln changed names to Harris Elementary, in memory of longtime principal Mame R. Harris. It is still open as the Harris Bilingual Immersion School. (FCM H08462.)

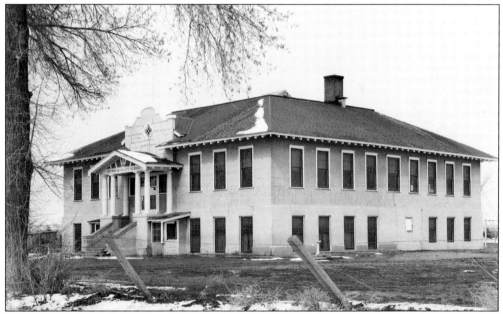

When the first German Russians arrived in Fort Collins to work the beet fields, the school district opened a school in a church in Andersonville. Rockwood School opened in 1908 as a four-classroom building, but by 1921, growing enrollment forced expansion. This photograph was taken around 1931. The school on Ninth Street closed in 1965, becoming a warehouse for a roofing business. It was later demolished. (FCM H09558.)

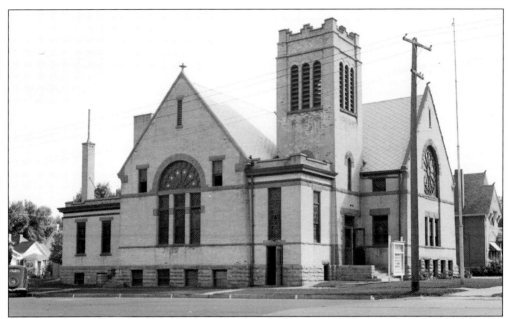

Architect Harlan Thomas designed the First Methodist Episcopal Church, 301 South College Avenue, to which the Millers belonged. The Methodists were among the first denominations to establish a church in Fort Collins, holding services in a frame building on Mason Street before building the College Avenue church in 1898. It served the congregation until 1964, when a new church was built on Stover Street, and the old one was torn down. (FCM H08924B.)

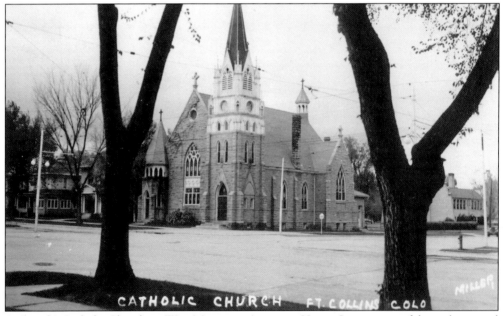

St. Joseph's Catholic Church on West Mountain Avenue at Howes Street is one of the architectural treasures of Fort Collins. Begun in 1901, led by Fr. Guillaume LaJeunesse, the church was built from locally quarried buff and grey sandstone. The soaring spire distinguishes this landmark. Remembered for his cat that understood only French, Father LaJeunesse quipped on his deathbed, "Someone just say three 'Hail Mary's' and mean them." (FCM H09079.)

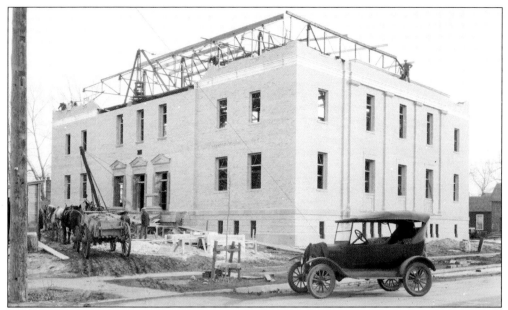

Masons have been active in Fort Collins since 1870. Over the years, Collins Lodge No. 19 grew and moved to larger quarters, all shared with other organizations or businesses. In 1921, the Masons, 600 members strong, felt they could support a freestanding temple. A committee quickly purchased a lot on the southeast corner of Howes and Oak Streets, and on October 14, 1925, the cornerstone was laid. Miller was hired to take photographs of the construction process. The photograph above, dated February 1, 1926, is one of this series, showing a partially completed temple with building materials being delivered by wagon. The photograph below shows the temple in 1969, with an office building on the east side and mature trees on the west. (Above, FCM H15899; below, FCM H08475.)

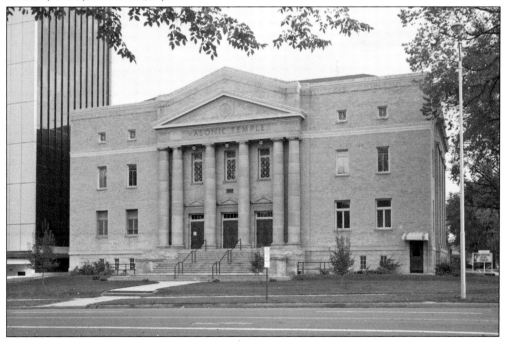

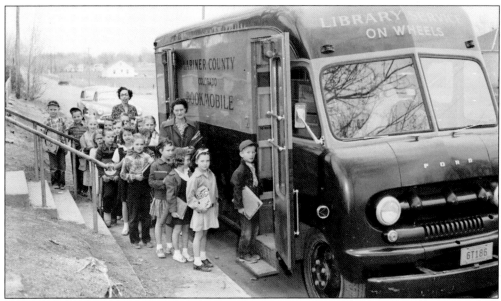

For families in outlying areas, the yellow bookmobile with its collection of more than 4,000 books was a welcome sight. Financed through Work Projects Administration funds in 1939, the Larimer County Bookmobile also visited schools. There were no fines for overdue books, and a lost library card was not a disaster. When the city and county libraries merged, the city library took over operation of the bookmobile. The city bookmobile became Yeller Feller and visited nursing homes, the fashion mall, rehabilitation centers, and rural areas all over the county. The service ended in 1981. (Above, FCM H18188A; below, FCM H18188.)

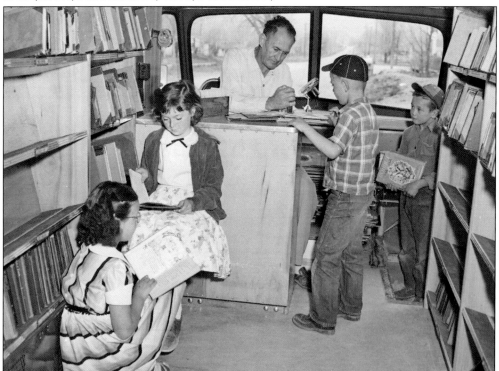

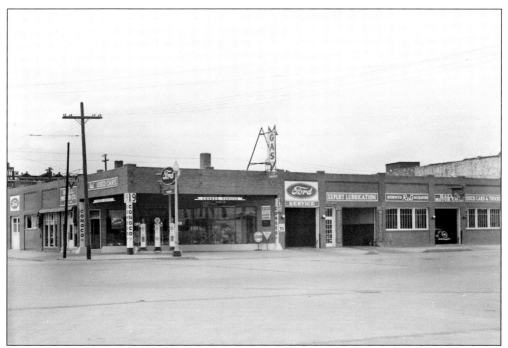

Ubiquitous today, automobile garages were a new thing at the dawn of the 20th century. An article in an August 1906 local newspaper described a garage as an "auto livery stable." Hall's was an early automobile garage in Fort Collins. Located at 205 North College Avenue, it opened around 1913 and served Fort Collins motorists for many years. (FCM H08468B.)

Was there a gas war going on? Merchants luring customers with lower gas prices were fairly common for years. At House and Humphrey, 163 West Mountain Avenue, motorists could fill up for only 15¢ per gallon. Despite its flawed upper right corner, this photograph was irresistible in these days of escalating gas prices. (FCM H10029B.)

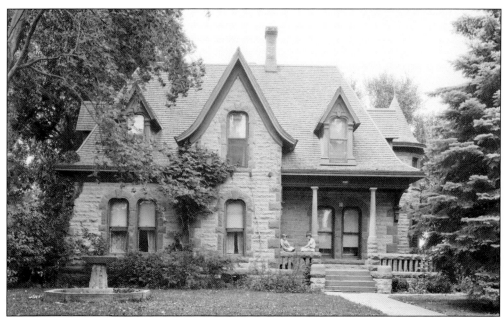

Fort Collins has exceptionally wide streets thanks to Franklin Avery. His beautiful home at 328 West Mountain Avenue cost $3,000 when it was built in 1879. A prominent citizen in Fort Collins, Avery started a bank and helped develop water sources for agriculture. In 1974, the Poudre Landmarks Foundation purchased the building, which is listed on the National Register of Historic Places. (FCM H06182.)

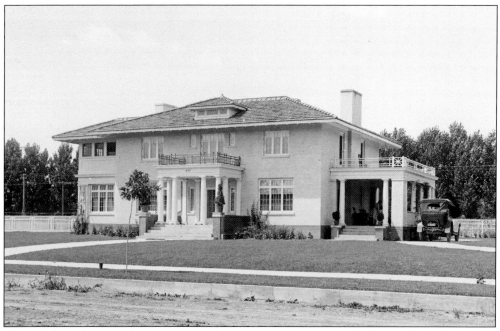

Strapped for cash during the Depression like many an entrepreneur, J. D. Forney devised a portable welding tool for farmers that grew into a local business, financed this elegant home at 400 South Grant Street, and supported a sizeable collection of antique cars that eventually became the Forney Transportation Museum in Denver. (FCM H15618.)

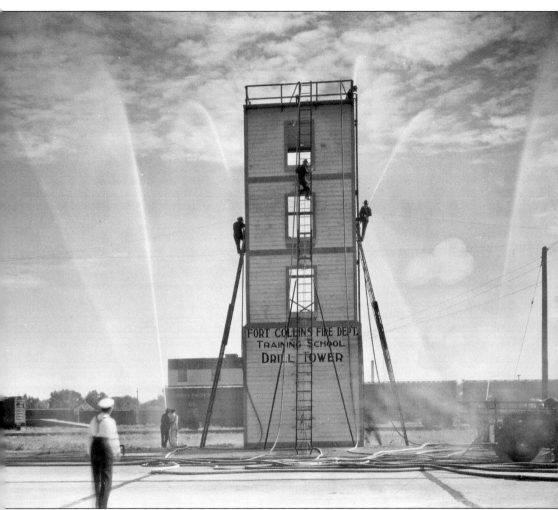

In Miller's time, firemen practiced their skills by scaling this fire tower on the north side of the 300 block of Jefferson Street. In the frontier town's Wild West days, volunteers fought fires with bucket brigades. Later teams dragged hoses from a horse-drawn water wagon. A huge bell, costing $200 and weighing 1,000 pounds, alerted residents when a fire broke out. The fire department was officially organized in 1915. (FCM H01968.)

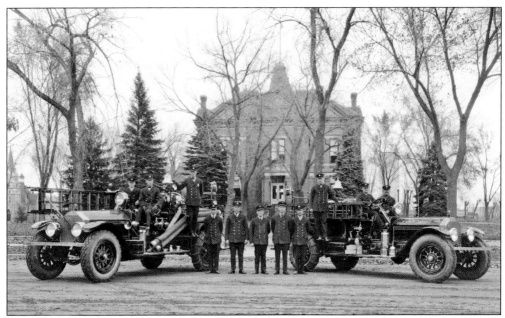

Fire was a huge problem in Fort Collins in the early days before brick buildings, a municipal water supply, and a fire department. Motorized fire trucks came as a real blessing to the town in the early 20th century. These trucks and crews pose in front of the courthouse at 225 West Mountain Avenue. The courthouse was demolished in 1950. (FCM H09593.)

Shiny fire trucks sit in the firehouse, 238 Walnut Street, awaiting a signal from the fire alarm at left. The building also housed the city hall, police headquarters, and a jail until 1976, when the new city hall on West Laporte Avenue was built. The fire department stayed a few years longer. The firehouse now contains a market and bakery; the interior fire pole is still there. (FCM H09856.)

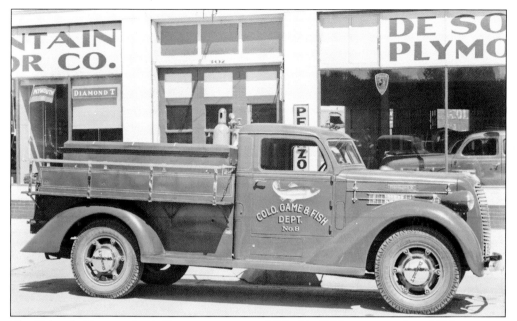

The Colorado Game and Fish Department was established in 1897 to manage the wildlife resources of the state. In 1901, while trying to stop a band of Native Americans from poaching deer, its second commissioner, Charles W. Harris, was wounded and his horse was shot out from under him. By the mid-1930s when this photograph was taken, the job was probably safer, and horses were being replaced with trucks. (FCM H08469.)

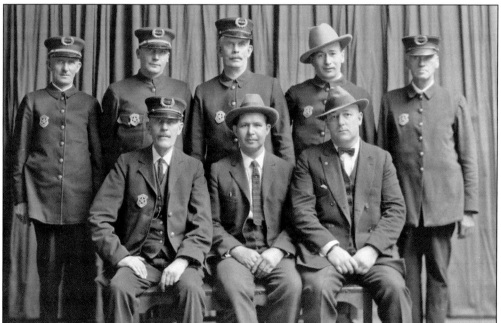

Taking a momentary breather from law enforcement, the entire Fort Collins Police Department poses for a formal portrait on September 12, 1925. From left to right are (seated) police chief Albert C. Baker, Mayor Frank Montgomery, and Chester C. Shay; (standing) Jess Morgan, Marion C. Short, Jim Johnson, Tom Flannery, and Lee West. (FCM H02340.)

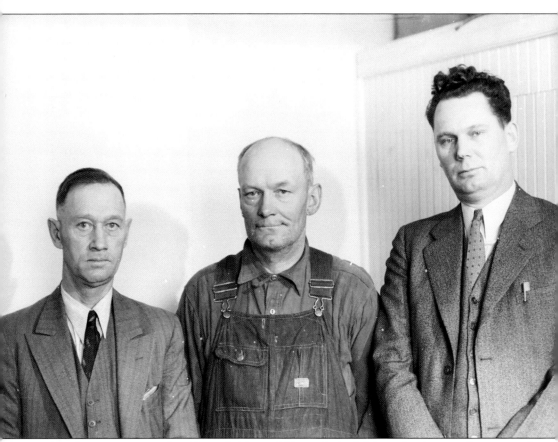

He almost got away with it. He probably would have if it hadn't been for the coat. Sometime after he murdered rancher Judd Walker, 63, in February 1935, Fred Hoflund appeared in Fort Collins wearing a coat belonging to the slain man. Walker's stepson saw Hoflund, recognized the coat, and quickly notified authorities. The circumstances were suspicious; a few weeks earlier, Walker's cousin, Gene Van Zant, had reported Walker missing. Nothing to do with him, Hoflund insisted. Walker left on February 4, telling Hoflund he was going to Denver. He just hadn't come back yet. But there was Walker's coat. Under continued questioning, the killer finally confessed: he had shot Walker after a dispute over some jointly owned chickens. He cleaned the body and hauled it to a cave half a mile from Walker's house, where he had buried his victim. The picture shows Fred Hoflund (center) flanked at right by Sheriff George Saunders and on the left by an unidentified man. (FCM H09940A.)

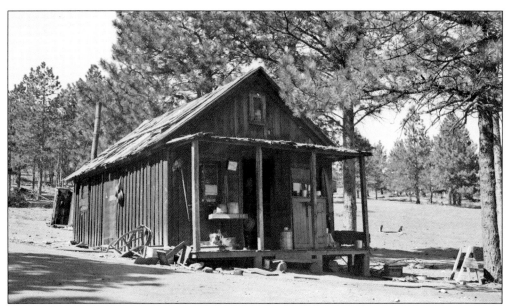

During the Depression, many people helped their less fortunate brethren by providing food and occasionally shelter. Nearly always, the reward was deep gratitude and sometimes help around the house or farm. Judd Walker wasn't so lucky. A widower, he lived alone in the mountains. He befriended Hoflund, allowing him to live in a cabin on his property. He probably never imagined that his reward would be a fatal shot in the neck. The day after the body was found, just where the killer said it would be, Miller accompanied law enforcement officials to the site to take pictures. He photographed Hoflund's cabin inside and out. Hoflund was charged with first-degree murder. (Above, FCM H09902; below, FCM H09903.)

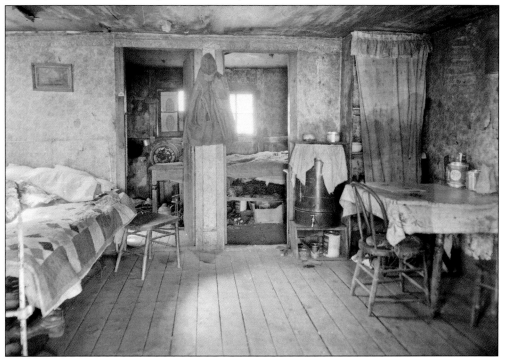

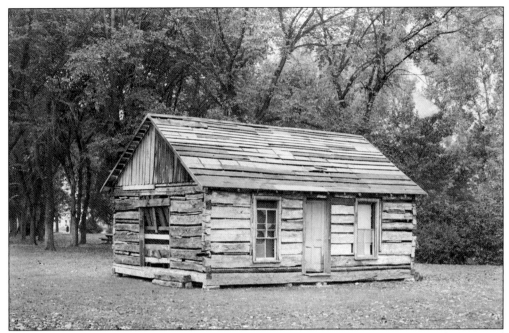

Antoine Janis came to the Poudre Valley in 1848. He returned 10 years later to settle here and built this cabin, now on the grounds of the Fort Collins Museum. Janis, who joined his Sioux wife at the Pine Ridge reservation during a forced relocation of Native Americans in 1881, is considered the first settler in the valley. (FCM H08934A.)

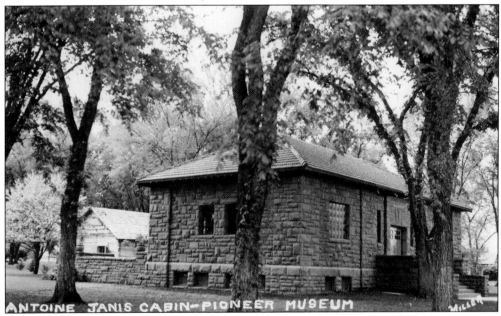

David Watrous, nephew of pioneer newsman and author Ansel Watrous, was the longtime curator of the Pioneer Museum. Built in 1942 of native sandstone, the museum faced onto Peterson Street. When it was demolished in 1976 to make way for a new library, the museum's priceless artifacts of early settlement found a new home in what had been the city library and is now the Fort Collins Museum. (MEM.)

Three

ON THE CAMPUS

Colorado's land grant college (nationwide educational institutions made possible by the Morrill Act of 1862) not only gave Fort Collins an academic toehold, but also saved the small frontier town from fading into obscurity. Although the territorial governor established the Agricultural College of Colorado in 1870, it took several years for words on paper to become students in classrooms. In 1874, a small brick "claim shanty" was erected on land donated by local businessmen, and Grange Number 7 plowed and planted several acres of wheat, thereby securing the college for Fort Collins.

Five more years would pass before the first president, Elijah Edwards, welcomed the inaugural class of students—all five of them—to Old Main, built in 1878. Over time, the college grew slowly and steadily. In the early years of the 20th century, a shift in educational philosophy moved curricula from focusing primarily on agriculture and mechanical arts into broader studies. In the 1920s and 1930s, the college's extension service provided priceless instructional assistance to farmers and their families.

When a generation of young men went off to World War II, women stepped in to teach; many of them continued teaching after the war ended. The influx of veterans after World War II, attending college on the GI Bill, led to the creation of a veterans' village, a cluster of Quonset huts on West Laurel Street.

The campus Miller knew had not yet expanded much. Most activity still teemed around the grassy, tree-lined oval. Locals with long memories can recall a dairy barn and pig farm where resident apartments now stand, west of Shields Street. Students still celebrated College Day every spring with a parade and festivities.

Nineteenth-century pioneer students and faculty—and maybe Miller himself—could not have envisioned today's university, covering hundreds of acres, having a faculty of 1,400 and a student body well over 20,000, and boasting a world-class college of veterinary medicine, among other outstanding programs.

Then (as now) college and community were firmly intertwined—and back then, the college, like Miller's Fort Collins, was a small, friendly place, a place that knew no strangers.

Charles Lory, for whom the college student center and a state park west of Horsetooth Reservoir are named, enjoyed the longest tenure of any president of the college, beginning in 1909 and lasting 31 years. Growing up on a farm, Lory had keen sensitivity to the needs of Colorado agriculture. He shepherded the college through the Depression and the gradual, steady growth of the student body and curriculum. (FCM M08132.)

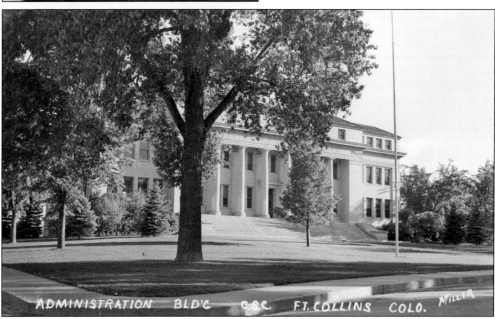

Even though the campus has gravitated south and west, and the Lory Student Center is now the focal point, the stately administration building at the southern tip of the oval still houses the president's office. During William Morgan's administration, it was occupied for a few days in the restive 1960s by student protesters. (FCM H08737.)

50

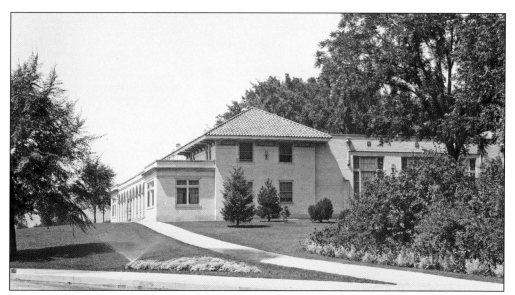

Originally known as the Women's Club Building, Ammons Hall opened on the oval in 1922 as a combination women's athletic and social center for the 240 women enrolled at that time. Designed by Eugene Groves in the Italian Renaissance Revival style, it has rounded doorways and decorative detailing under the eaves. It is one of three campus buildings on the National Register of Historic Places. (FCM H08743.)

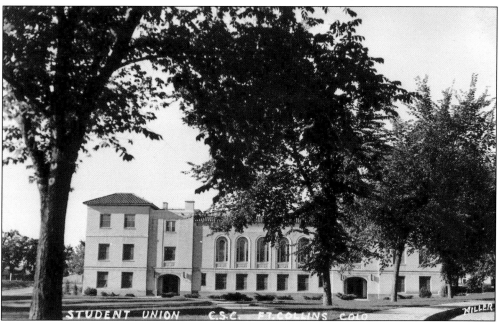

After students lobbied for a gathering place and agreed to assess themselves to pay for it, in 1932, the college erected Johnson Hall, which featured a cafeteria, ballroom, and study areas, and later served as the drama department's performance hall. In 1962, a new student union, the Lory Student Center, replaced Johnson Hall, which has become part of the administrative facility. (MEM.)

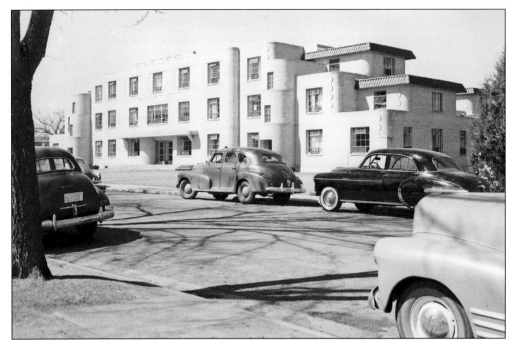

Heralded as innovative, the first dormitory built to house men, Braiden Hall, proved a disappointment when it was erected in 1948. Says college historian James Hansen, it was "dark and dismal" inside, with narrow hallways and stairwells, and "a compass was required" to get around. The unwieldy design led to building dormitories with easily navigable wings. (FCM H17842B.)

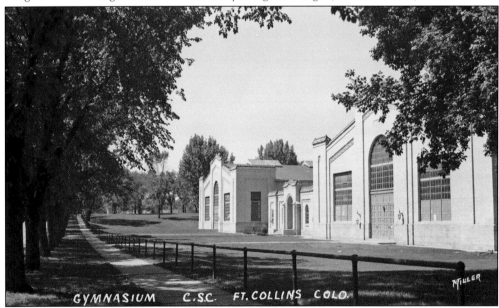

The college's first gymnasium/field house was built on South College Avenue in 1924. Long the center for men's athletics, it is also remembered for an event that occurred the day Miller died, May 8, 1970: A student strike was underway in the gymnasium when Old Main was set ablaze. The destruction of the 92-year-old campus cornerstone reminded students that actions have consequences; the protests withered away. (FCM H08733.)

Perhaps more than anyone else, Prof. Burton Longyear influenced the development of the college forestry department. In 1914, he joined Charles Lory and H. N. Wheeler on an excursion via Stanley Steamer to national forest land designated for college use by Congress. They walked the last several miles through rugged terrain to get to the site, which became the Pingree Park campus. (FCM M06272.)

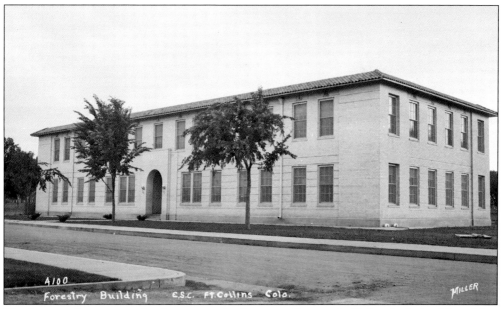

The forestry department that Longyear, the first state forester in Colorado, helped found has become part of the Warner College of Natural Resources, encompassing forest, rangeland, and watershed stewardship, with offices in this building. It was designed by Eugene Groves, one of 13 buildings he created for the campus, and was built in 1937. (FCM H08736.)

The college library had been in Old Main until it moved into this building on the west side of the oval in 1905. The building served as the library until 1964, when Morgan Library, named for former president William E. Morgan, was built. Miller's son Warner, who graduated from the college and became dean of students, probably studied here, as did Beth and Keith Miller, who also became educators. (FCM H08742.)

George Glover was only 15 when he came to the college in 1880, arriving in a horse-drawn wagon. He graduated with the first class in 1884. A few decades later, he was instrumental in persuading lawmakers to establish an accredited veterinary school, which became a reality in 1907 and specialized mostly in large animals for many decades. (FCM H17970.)

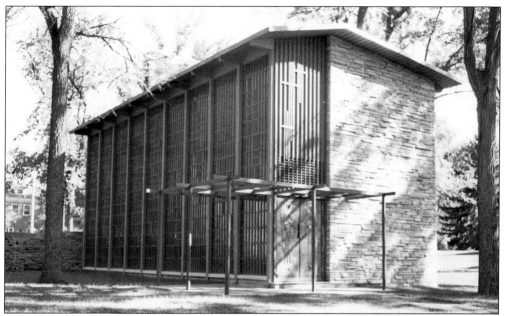

The intimate, lovely chapel at the north end of the oval was built in 1954 for use as a nondenominational site for services, weddings, and other events. It is one of 24 meditative chapels built on college campuses by William Danforth's philanthropic foundation. Danforth, a devout Christian, founded the Ralston Purina Company. With its distinctive styling inside and out, the building has won several architectural design awards. During the civil rights struggles, a group of African American students led a march honoring Martin Luther King Jr. from the chapel to the Lory Student Center. (Above, FCM H09488D; below, FCM H09488C.)

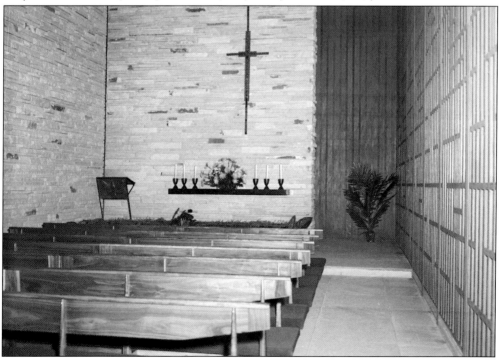

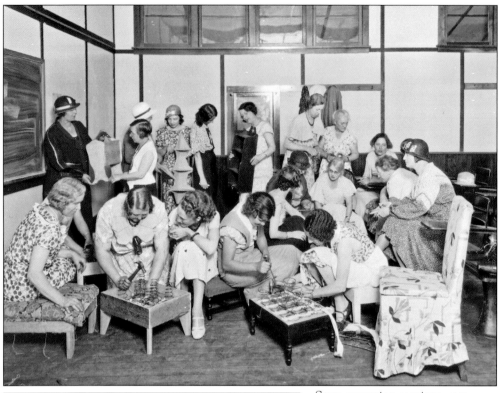

State extension services were aligned with and implemented through land grant colleges and county agents. In the beginning, only a few agents covered the entire state of Colorado. The service aided farmers with pest control, herd management, and other agricultural concerns, but the service also provided classes in domestic sciences, including sanitation, landscaping, nutrition, clothing, home management, child development, parent education, and even, as shown in these two photographs, upholstery, painting, and decorating. (Above, FCM H06972; left, FCM H06954.)

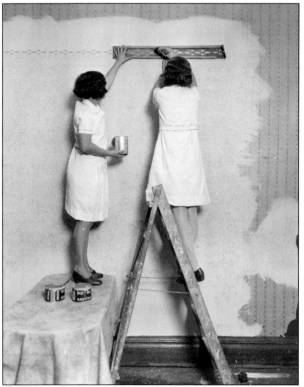

The concept of an extension service was born in the 1880s with farmers' institutes, but it was not formalized until the Smith-Lever Act of 1914. An early goal was broadening the education and domestic skills of rural homemakers. Hand-knit hosiery is on display in the photograph above; in the photograph below, young girls display a gingerbread house they learned how to make in an extension service class. One outgrowth of extension services was 4-H clubs. Now, more than 100 years later, the college extension service is "your front door to the research, information and expertise of your land-grant university," according to its Web site. (Above, FCM H06960; below, FCM H06969.)

Glenn Morris was obsessed with winning the Olympic decathlon, so he stayed in Fort Collins after graduating from the college. He took part-time jobs to support himself and trained in every spare moment in all kinds of weather. In his first decathlon competition in the United States, he set a new record, earning him the right to compete in the 1936 Olympics in Berlin. Bathed in glory after winning the gold medal there, honored in Colorado with a parade and ceremonies, he tried various careers: radio announcer for NBC, the role of Tarzan in a film, and professional football. But nothing quite worked out, and his star faded fast. Severely wounded during World War II, he disappeared into obscurity. His death in 1974 garnered little attention from either his alma mater or the press. (FCM M07637.)

Nicknamed "Fum" in childhood, Thurman McGraw was an exceptional athlete who excelled in sports in high school and college, and who enjoyed a successful career in pro football until sidelined by injuries. Returning to Fort Collins, he became the college athletic director and led the drive to build Hughes Stadium. The Thurman McGraw Athletic Center on the west end of the campus preserves his memory. (FCM M20417.)

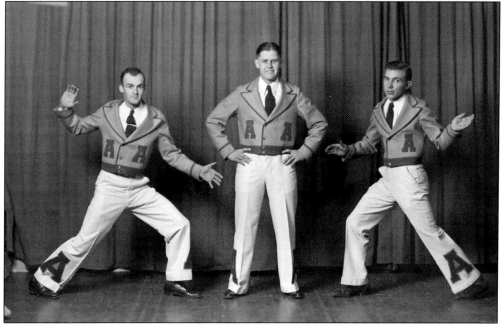

A symbol of the school they were so enthusiastically supporting, the large Aggie "A" on the flared legs of these uniforms leaves no doubt about which school it is. This photograph may have been taken in the auditorium at Old Main where these "yell leaders" were leading a pep rally before a big game. (FCM M18019.)

These majorettes, photographed around 1940, would have performed at football games and other events. Miller probably made the photograph for the *Silver Spruce*, the college yearbook. Photographs of individuals and groups for college and high school yearbooks were a significant part of his business. Prior to World War II, Fort Collins's three main photography studios—Miller, Fishback, and Kalm—worked cooperatively to cover the highly seasonal school business. They agreed on backgrounds and layouts so the finished photographs had a common appearance. But they apparently went further, also agreeing on offerings and pricing, and taking turns doing group photographs. New studios opened up after the war, bringing competition and ending a long cooperative period. (FCM H17938.)

College Day began as an annual picnic in 1910. That year, a special Colorado and Southern train left the depot at 9:00 a.m. carrying students, faculty, alumni, and seven cars of food to nearby Bellvue for a day in the foothills. Sixty cents covered the fare and dinner prepared by the domestic science department. In 1921, the students moved the celebration to the campus. Over time, College Day became an all-day Western celebration with a parade, rodeo, and barbecue. The Aggie cowgirls (at right), from left to right, Irene Alford, Virginia Showalter, Philippine Anderson, and Jimmie Lue Nisbett, were probably part of the festivities. The popular parade featured floats from student Greek organizations. This float (below), lovingly fashioned by the members of Kappa Delta sorority, probably kept its creators up all night. As the college grew larger and more urban, the celebration faded away. (Right, FCM H17921; below, FCM H17973A.)

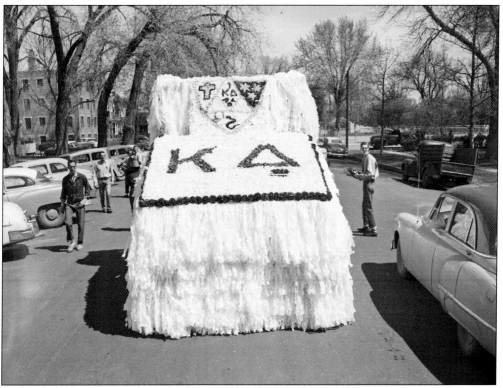

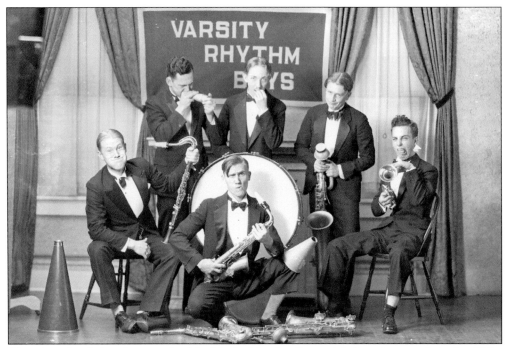

Though undated, this photograph of the Varsity Rhythm Boys might have been made in the 1930s, at the height of the jazz craze in America. These unidentified musicians appear to be having a wonderful time playing and clowning around together. (FCM H18015.)

LOVER'S LANE C.S.C. FT. COLLINS COLO MILLER

For decades, the oval was the center of campus life. "Lover's lane," the tree-lined walk down the middle, was a favorite spot, especially for courting couples. As a college student in the 1920s, J. D. Forney, who would later open an automobile museum, got a ticket for speeding around the oval while courting his wife, Rachel Krickbaum. No longer the focus of campus activity, the oval still occasionally hosts spring weddings. (FCM H08740.)

Four

SWEET PROSPERITY

Perhaps more than any other single event, the arrival of a sugar beet factory propelled Fort Collins into the 20th century and the industrial age. The high-plains climate proved well suited to this large root crop; by the dawn of the 20th century, processing factories began to appear in Colorado. Denver entrepreneur Charles Boettcher and others saw the potential for a Fort Collins plant. It opened here in 1904 near the river and the railroad tracks on the east side of town, heralded with a joyful "sugar day" celebration.

The presence of the factory increased and diversified the population: growers and harvesters came from afar, beginning with German Russians. More than a century earlier, German farmers had been lured to Russia by Catherine the Great. These skilled farmers knew sugar beets. When, under Catherine's successors, they found themselves less and less well treated, they began emigrating to America, arriving in Colorado by the hundreds ready to work. Where to put all these workers? Factory owners provided housing, small frame structures that the new residents built themselves then paid off in small increments over several years.

In 1916, unrest in Mexico drove many residents north, some as far as Colorado. Soon Mexican immigrants had largely replaced the Germans in the original developments of Andersonville and Buckingham near the factory. Another development, Alta Vista, was added in the 1920s. The European settlers fanned out into the town or onto farms, while the Mexicans mostly stayed in the settlements and built adobe houses, a few of which still stand.

Harvesting sugar beets required patience, endurance, and strong backs. A special tool, held at just the right angle, lopped off the beet tops in a process called topping. Harvesters were paid by the ton, so efficient topping was important. Getting the job done fast required every available worker, child or adult, to labor in the fields.

The Great Western Sugar Company operated in Fort Collins until 1955, as Fort Collins was evolving from an agricultural to a more urban community. Part of the factory complex remains, remodeled into a city facility.

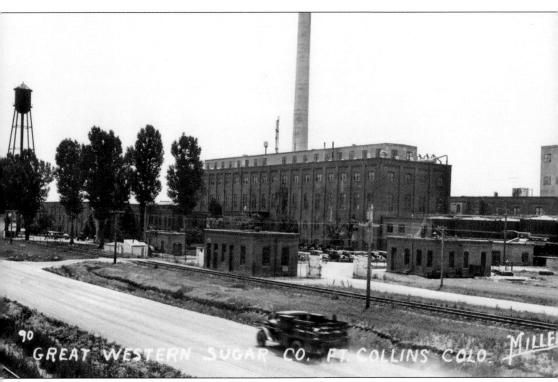

On Monday morning, January 6, 1904, the Fort Collins sugar beet factory began to refine sugar. Located on the southeast corner of Vine and Linden Streets, the factory had seven major buildings, the central building measuring 70 feet by 300 feet and standing four stories tall. The facility cost a staggering $1.2 million and employed hundreds of workers. The factory received sugar beets from farmers' wagons and railcars, and sent them through a complex, multi-stage process that produced refined sugar. But the sugar beet business was more than a factory. It was also a network of beet farmers, beet dumps, irrigation ditches, and a host of suppliers, all funneling money into the community. The 150-foot smokestack declared that big agribusiness had arrived in Fort Collins. (FCM H01806.)

Sugar beet plants began operating all over Colorado at the beginning of the 20th century—but not in Fort Collins. A committee of business and community leaders raised the capital to build a factory and got guarantees from farmers for 5,000 acres of sugar beets. On October 13, 1903, the committee made its first payment to Kilby Manufacturing for the Fort Collins factory. (FCM H03418.)

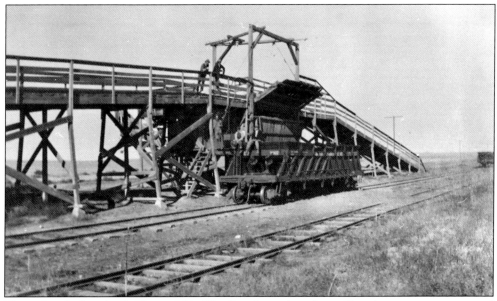

The railroads placed rail sidings within 10 miles of most beet farms. Beet dumps were constructed adjacent to the sidings. At low-tech dumps, farmers shoveled the beets in by hand, but at the Black Hollow Beet Dump, near Severance, Colorado, wagons with modified beds were pulled up to the ramps and dumped into waiting railcars. (Note that this is not a Miller photograph.) (FCM H09317.)

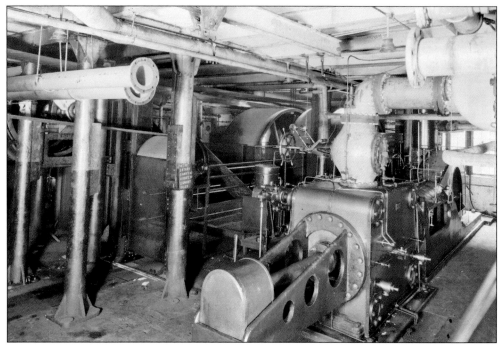

As this photograph shows, sugar refining was as much a chemical as an agricultural process. Pumps, pipes, slicers, distillers, centrifuges, and filters were all part of a highly technical process that produced an average of 10 teaspoons of refined sugar from each beet. (FCM H09881.)

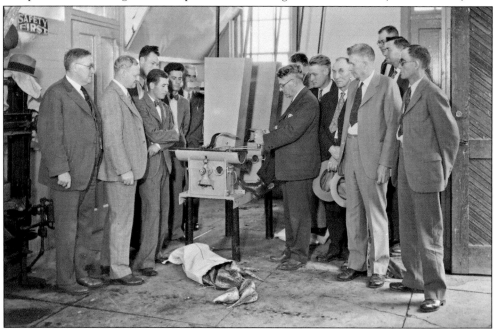

The two groups most important to the sugar beet process were the chemists and the farmers. In this photograph, beet farmers in suits with hats in hand watch a chemist demonstrate a piece of equipment, possibly a beet slicer. An opened bag of Front Range sugar beets is on the floor. (FCM H03443.)

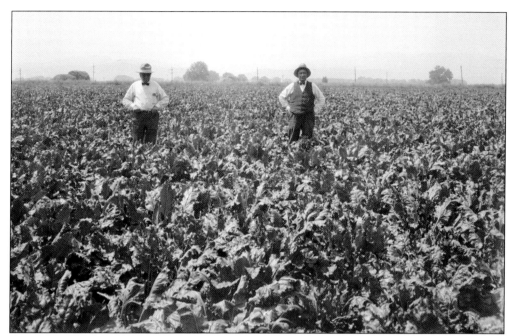

Even before the factory was completed, beet farms sprang up around Fort Collins. Beets required precise farming techniques and were labor intensive, but they generated more income for farmers than any other crop. Miller photographed many farmers standing amid their crops, displaying their pride in their fields. (FCM H03442.)

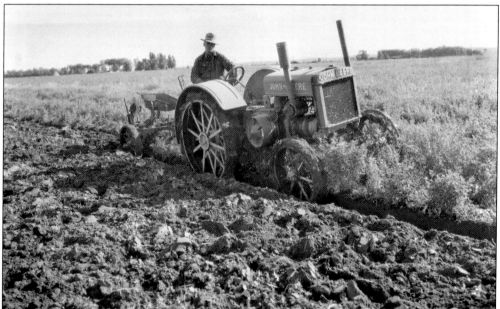

Beet farming required plowing, multiple harrowings, and leveling (for proper irrigation), all extremely difficult with horse-pulled plows. Tractors were a godsend to beet farmers, but their cost meant tractors would be slow to replace horses. In 1920, only eight percent of Northern Colorado farmers used tractors. This percentage grew slowly; even by 1940, only 37 percent of Northern Colorado farmers used a tractor. (FCM H03447.)

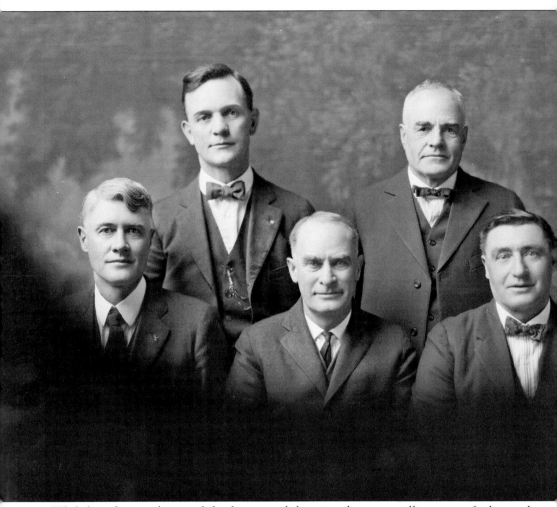

While beet farmers distrusted the factory and the price they were willing to pay for beets, they respected the factory's "fieldmen," who were experts in growing sugar beets. Each farm had an assigned fieldman available for counsel on plowing, planting, thinning, harvesting, or any problem or question associated with sugar beets. Learning from their daily contact with beet farmers and factory experts, the fieldmen shared their knowledge with their farmer clients. In a newspaper advertisement, the Great Western Sugar Company called fieldmen the "clearing house for best methods practiced in the district." This mid-1920s photograph shows Northern Colorado fieldmen, from left to right, (first row) C. F. Osborn, H. H. Griffin, and Charles Willox; (second row) Harvey Riddell and Jack L. Houser. (FCM H03425.)

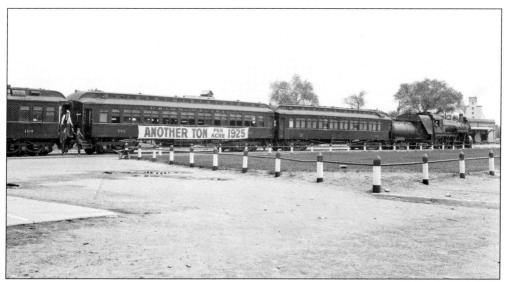

Trains were common in the early 20th century, and the Great Western Sugar Company found a creative use for them. In May 1925, the "Big Beet Special" (above) rolled into Fort Collins, challenging beet farmers to add "Another Ton per Acre" to their sugar beet yields. To help the farmers, the railcars were outfitted with exhibits that showed how proper beet farming techniques paid off in higher yields. The sugar company was not alone in using demonstration trains. The extension service also used trains to teach progressive farming techniques, sometimes including an extra car for a lecture room. (Above, FCM H03336; below, FCM H03432.)

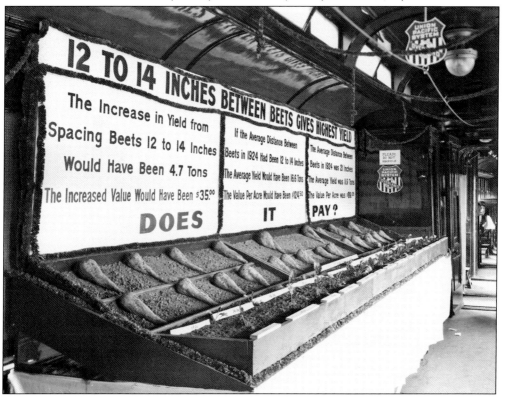

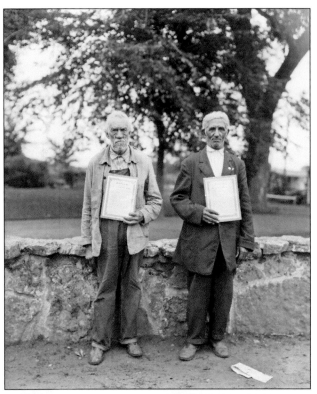

The sugar factory also strove to raise beet yields through recognition and contests. Farmers with the highest yield per acre in the district were invited to the factory to receive a certificate and to get their photographs taken. Miller was often the photographer. Contests could result in significant payouts. One contest in 1903 paid $400 to the farmer with the highest yield. The large group below stands in front of the Fort Collins YMCA building at Oak and Remington Streets. The building, purchased by the Elks in 1940 and extensively remodeled after the downtown explosion in 1977, now may be torn down for a new hotel and conference center. (Left, FCM H03437; below, FCM H00158.)

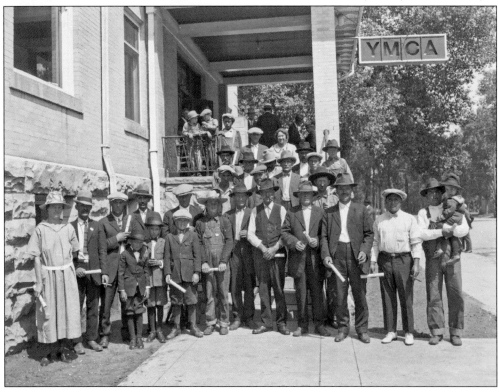

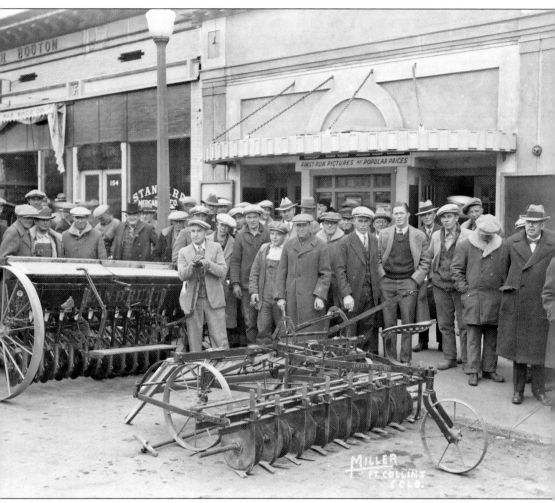

Any device that could reduce the manual labor of beet farming was sure to draw a crowd. This group is in the 100 block of West Mountain Avenue. The piece of equipment at left is a combination field drill and fertilizer that could be used to plant seeds. A cross-row blocker is in the foreground. Each beet seed produced two to seven seedlings. Unfortunately, sugar beets grow best as single plants 12 to 14 inches apart, making thinning important. Thinning required two steps: first, the beets were blocked by workers using hoes to cut seedlings out of a solid row, leaving small tufts. Second, other workers manually pulled all but one seedling from the remaining tufts. Mechanical blockers would eliminate the first manual step. (FCM H03444.)

Front Range rainfall was not sufficient for sugar beets, so the fields had to be irrigated. New irrigation ditches were dug from the Poudre River to the beet farms. The increase in irrigated acres was a long-lasting benefit of the beet industry. (FCM H09790.)

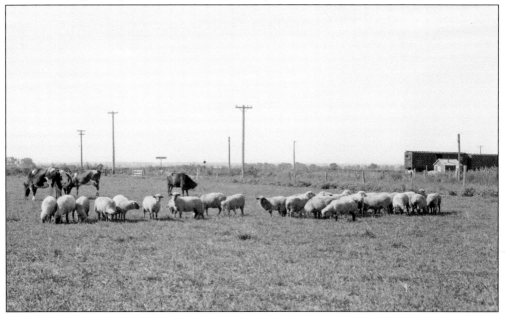

Experiments by the agricultural college and others found that the waste products of the beet industry—beet tops, beet pulp, and molasses from the factory—made nutritious feed for livestock. This fostered cattle and sheep industries in Northern Colorado. Beet pulp had an odor that one man compared to "a slaughterhouse in midsummer," but former Colorado governor Benjamin Eaton remarked, "I smell prosperity." (FCM H03445.)

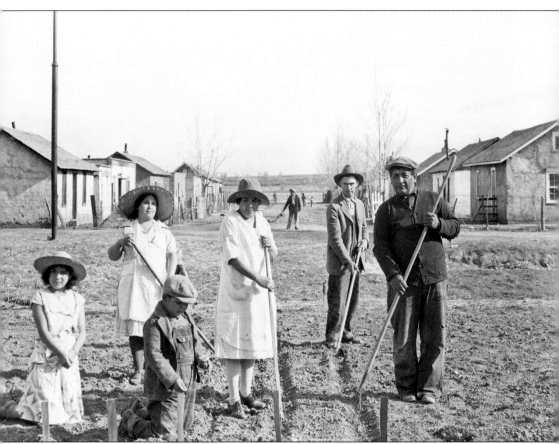

This family, working in their private garden, was undoubtedly sugar beet workers, probably Mexican immigrants living in one of the adobe houses in the background. Mexicans came to the United States in large numbers during the Mexican civil war. Like their predecessors, the German Russians, they were used to making their living from the soil. Japanese immigrants also came to Colorado to grow sugar beets, though in smaller numbers. Language was a barrier; older generations often spoke limited English. Customs and traditions long observed in "the old country" came with families to their new homes. In an effort to keep the workers year-round, the factory provided small homes, 12 feet by 20 feet, that the workers built themselves in Buckingham, Andersonville, or Alta Vista. (FCM H17795.)

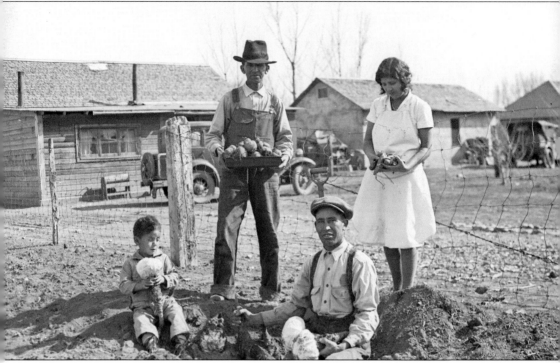

Assimilation of the workers into the Fort Collins community was not easy; they encountered discrimination in their new country. The German Russians often heard themselves called "dirty Russians." During World War I, some of these immigrants altered the spelling of their names to avoid anger directed at a distant enemy. For decades, Mexicans encountered signs in town refusing them service. During World War II, Japanese citizens were interned. An area near Buckingham, the first German Russian settlement, was labeled "the jungles," known as a place that harbored gambling and other illegal activities. The name stuck for a long time. And while the workers had homes like the frame homes shown in this photograph, they used wood stoves for heat and did not get basic services like plumbing and paved streets until the 1970s. Notice the primitive root cellar for storage in this photograph. (FCM H17797.)

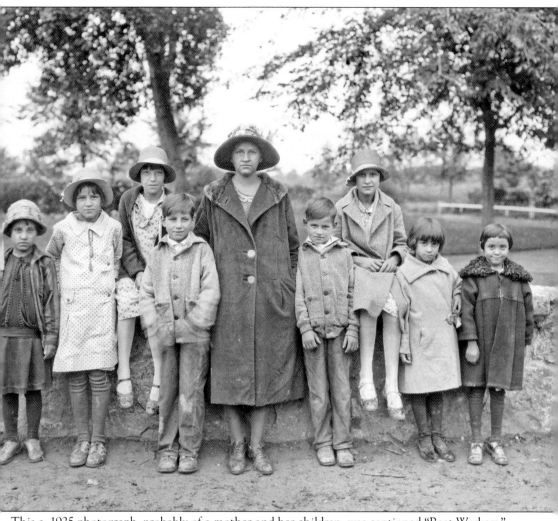

This *c.* 1925 photograph, probably of a mother and her children, was captioned "Beet Workers." It was an accurate caption; everyone worked in the beet fields. Even the youngest children were brought out to the field, where they were cared for by older siblings so the mother could work the beets. In her novel *Second Hoeing*, author Hope Williams Sykes describes a typical work day by a typical large family—an early, hearty breakfast, sandwiches and water carried to the fields for lunch, backbreaking labor in the fields from daylight to sunset for everyone except the youngest children. Children were allowed to attend school through eighth grade, as the law required, but high school was considered an unnecessary luxury. The 1930s brought child labor laws, protecting the children but making a hard business even harder. (FCM H03433.)

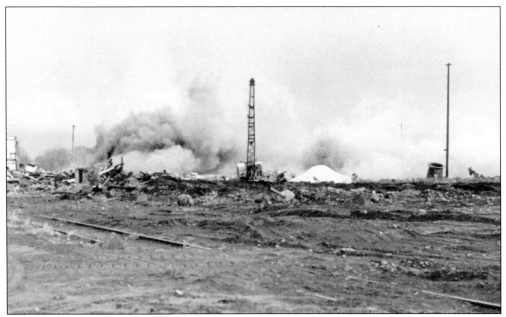

Wars, the economy, trade policies, and weather all impacted the profitability and viability of the sugar beet industry. Drought and high winds in the mid-1950s reduced sugar yields. The Fort Collins factory announced in 1955 that it would not operate, moving the harvested beets to other plants for processing. It never reopened. In 1967, the major buildings were razed. (Photographer unknown; FCM H21106.)

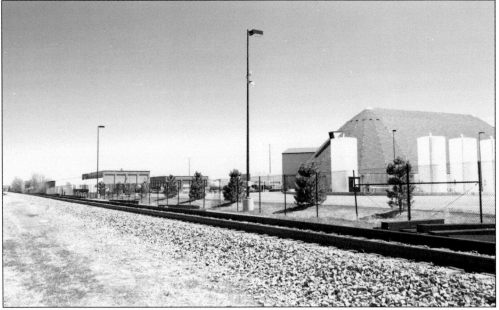

This contemporary photograph, taken by author McNeill, looks at the site from approximately the same spot Miller did years ago in the first photograph in this chapter (page 64). Today's view is much less impressive. Three original buildings remain, purchased by the city as a home for the streets department. But thanks to the industry, Fort Collins had grown and become a real player in the new 20th-century economy. (MEM.)

Five

FORT COLLINS AT WORK

Agriculture, the college, and the sugar factory were the major employers when Mark Miller set up his Fort Collins studio, while other ways to make a living in the small college town were limited primarily to satellite businesses that supported them, services such as shoe repair and tailoring, banks, cafés, and retail. Small enterprises like mom-and-pop grocery stores, bakeries, and milliners dotted the neighborhoods.

The first publicly supported hospital did not exist until the 1920s, although there were a few private hospitals and a county poor farm, which treated indigent patients. Doctors (including one woman) made house calls. Since Fort Collins was a dry town, the crime rate was relatively low, although the town of Stout, on the edge of the sandstone quarry west of town (where liquor was allowed), created a nighttime hotbed of drinking, quarreling, and an occasional shooting. By the 1920s, the quarry was shut down, the little town dwindling away.

For an entrepreneur like Mark Miller, who had a skill to sell, the setting was promising: not much competition, a thriving economy, and a growing population. During much of Miller's work life here, the town remained agricultural at its core, but he was witness to a steady broadening of business opportunities and an increasingly diversified population as the townspeople experienced two world wars (the second one followed by an influx of veterans), an oil boom and bust, the Depression, and, by the late 1960s, an end to local prohibition. After World War II, more and more women joined the work force here, as elsewhere. The landscape, climate, and college continued to attract people to Fort Collins; by the end of Miller's life, employment opportunities were many and varied, and were no longer primarily rooted in agriculture, even though agriculture still had a significant role to play.

A powerful work ethic prevailed among workers for most of Miller's lifetime: long days of hard work would yield just rewards, a belief as true for the photographer seeking just the right light as in the wider culture.

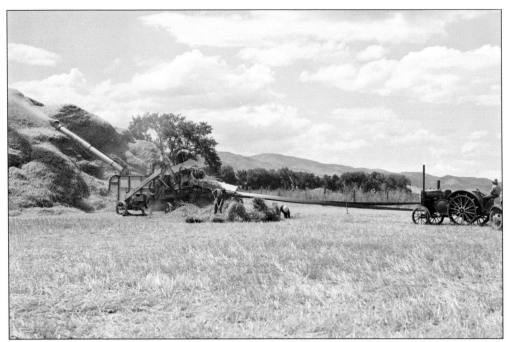

Agriculture remained Fort Collins's dominant industry for most of Miller's life; his negative files include many photographs of farms, ranches, farm workers, and haystacks. He made most of these photographs at the request of the farmers and ranchers. But we would hope that sometimes the motivation for a Miller photograph was nothing more than a beautiful scene found on a sunny Northern Colorado day, resulting in photographs like these two of a threshing operation on a local farm. (Above, FCM H09491; below, FCM H09494.)

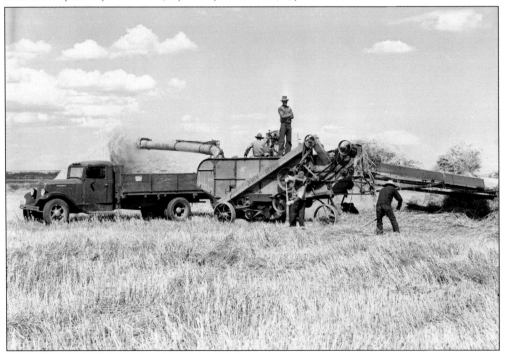

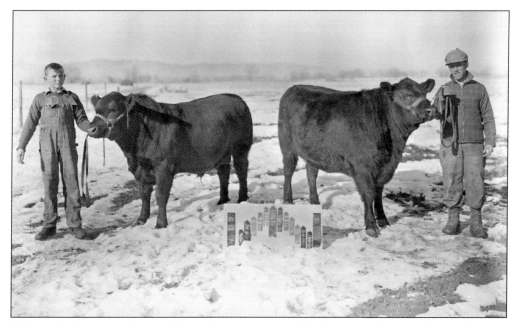

With agriculture come fairs and livestock competitions. The first annual Larimer County Fair was held in 1879 at a fairground on what is now Lemay Avenue, where Poudre Valley Hospital now stands. The National Western Stock Show and the Colorado State Fair soon followed. In this 1930s photograph, Bryan F. Shader (right) and his son, Raymond, show off their prize-winning Angus steers and their collection of ribbons. (FCM H03451.)

Hints that Fort Collins once had a fur farming industry have surfaced: a 1922 newspaper article proclaiming "the climate in Colorado . . . ideal for fox farming," a 1949 tax assessor record for a chinchilla house, Miller's photographs of the Wilson Chinchilla Farm (above), and an unverified story that fox sightings are common in Fort Collins today because numerous foxes were released when fur farming ended. (FCM H17840.)

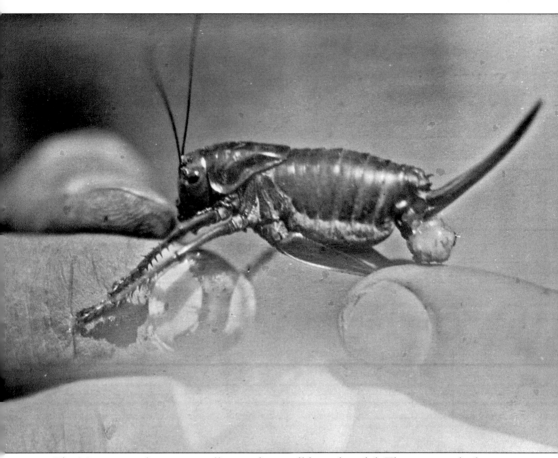

The Mormon cricket is not really a cricket at all but a katydid. This insect, which can grow as long as 2.5 inches, starts out harmlessly enough: hatching, growing, molting, and foraging for food. But then one cricket encounters another, and another, and soon they become a migrating band. In bad years, destructive hordes can be as thick as 100 per square yard. Miller probably took this photograph in 1938, during an infestation that covered 11 states and wiped out millions of acres of crops, to the despair of hardworking farmers. These insects have been around for thousands of years; the remains of cooked crickets were found during an archeological excavation in Wyoming. They acquired the name Mormon crickets when they severely threatened the 1848 Mormon settlement in Salt Lake City, Utah. (FCM H09115.)

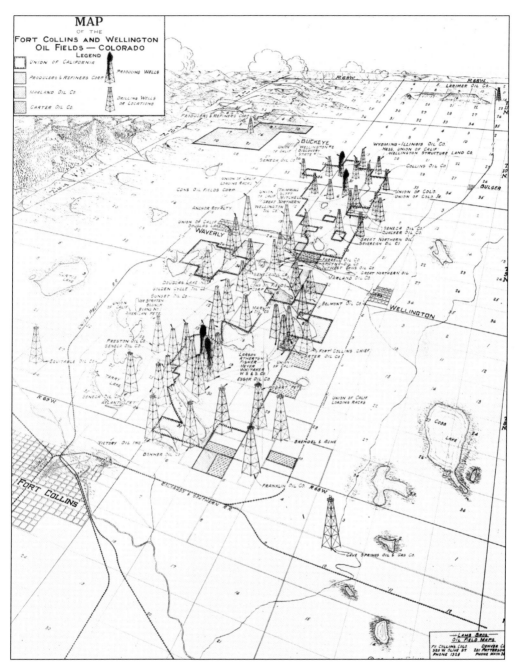

At 4:00 a.m. on Armistice Day (November 11), 1923, a "terrifying noise" announced that Union Oil had brought in the first well in the Wellington Dome. The Discovery Well, located 14 miles north of Fort Collins, was called "one of the biggest wells ever struck," leading the newspaper to predict that Fort Collins, then with a population of 9,000, would reach 50,000 by 1928. As the map shows, the field was large, spreading from Terry Lake in Fort Collins to north of Wellington. Speculators rushed in. Office space was at a premium. Prosperity seemed assured. Drilling was heavy through 1926, but by then, a drop in production was occurring, and by 1930, the industry had faded from public notice. Fort Collins's population stood at 11,500 residents. (FCM H06222.)

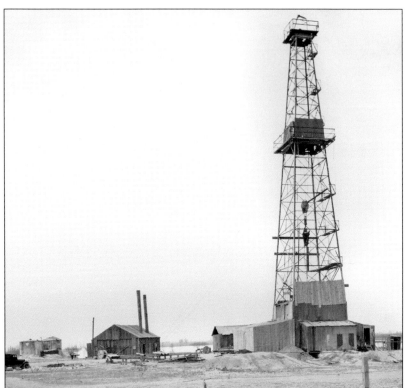

Union Oil brought in the Discovery Well on Armistice Day and drilled most of the exploratory wells in the field. At one point, there were 34 producing wells, all owned in whole or in part by Union Oil. The wells came in as gas wells and then, over the course of a few days or weeks, oil would begin to flow. (FCM H09883.)

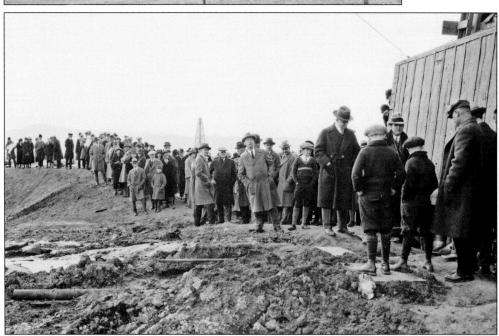

New wells drew crowds like this one at the Stratton Well. On one Sunday, an estimated 50,000 people visited the oil field, the "greatest crowd ever in Northern Colorado." In those days before environmental protections were in place, the public was allowed to visit but "instructed not to smoke or light matches on the premises." (FCM H09889.)

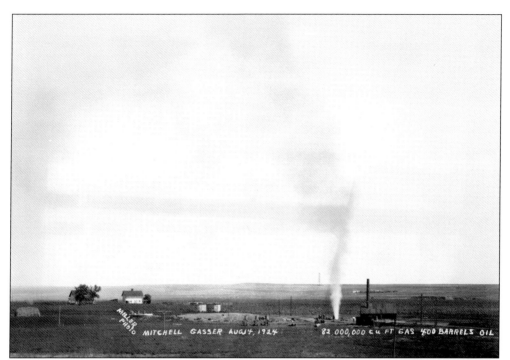

MILLER PHOTO MITCHELL GASSER AUG 14, 1924 82,000,000 CU FT GAS 400 BARRELS OIL

The Mitchell Well came in on July 19, 1924. It was a large well, throwing 82 million cubic feet of gas into the air every day. On July 23, an electrical spark set the well on fire, injuring seven workers and producing flames that could be seen from the tops of buildings in Fort Collins. The fire proved tough to put out but generated a spectacle for thousands of visitors, especially at night. The newspaper reported, "Soft drink stands and hot dog lunch counters have sprung up and are being patronized by the crowds." Finally, 24 days after the fire started, a 40-pound charge of nitrogelatin snuffed out the flames. (Above, FCM H09109; right, FCM H09110.)

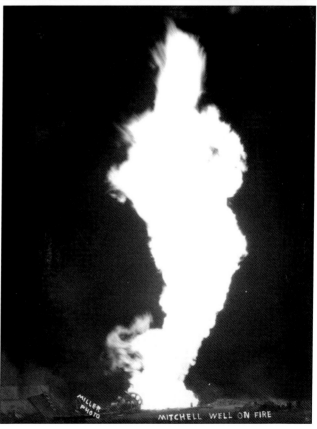

MILLER PHOTO MITCHELL WELL ON FIRE

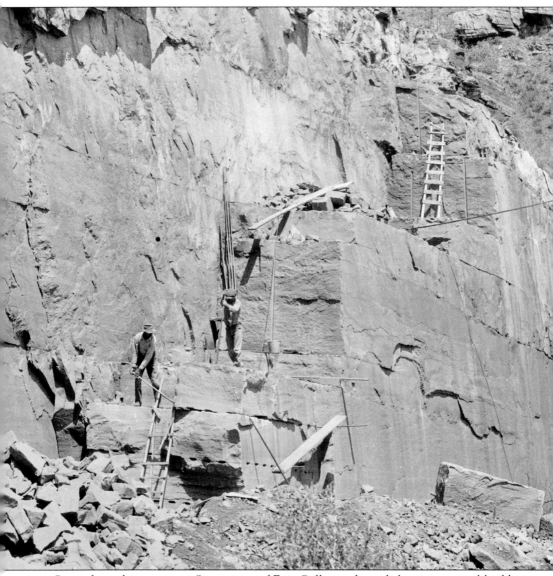

Stone from this quarry at Stout, west of Fort Collins, adorned the state capitol building in Denver and provided material for sidewalks, homes, and churches in Fort Collins. (Few sidewalks remain, but several homes and churches still stand.) Workers still chipped away at the stone for the first decade of the 20th century, but in the 1940s, the quarry and town were flooded to create Horsetooth Reservoir and a reliable water source for Fort Collins. Horsetooth Reservoir is part of the Big Thompson Water Project that moves water from the Colorado River over the continental divide through a series of reservoirs, pumps, tunnels, canals, and power plants to the Front Range cities of Loveland, Greeley, and Fort Collins. (FCM H06187.)

Charles Boettcher, who became one of the richest men in Colorado, began his career selling hardware in Laporte, northwest of Fort Collins. Deciding to build a cement plant in Northern Colorado, he remembered the place that gave him his start. The Ideal Cement Company, built in 1925, was a significant employer in the area for much of the 20th century. (FCM H08450U.)

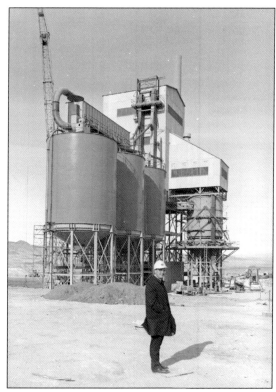

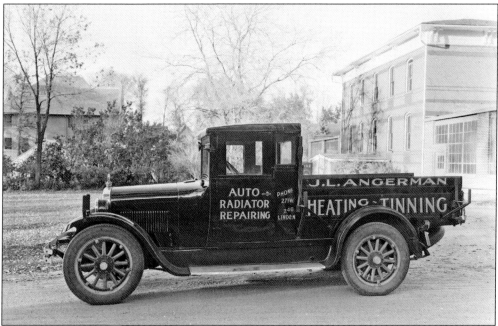

Miller took many photographs of commercial trucks. Tow trucks, gasoline trucks, even a truck delivering Coors 3.2 beer during the dry times ended up in front of his lens. But, as an example of this kind of photograph, who could pass up a radiator repairman named "Angerman"? (FCM H13371.)

In 1967, the Centers for Disease Control (CDC) merged their field station laboratories in Cache Valley, Utah, and Greeley, Colorado, into a single facility on the Foothills Campus of Colorado State University, and Miller was there to record the event on film. The university's extensive experience in vector-borne diseases, combined with collaborative opportunities between university and CDC scientists, made Fort Collins an ideal location for the facility. A year later, the CDC moved its San Francisco plague program into the facility, making it the focus for all diseases carried by mosquitoes, ticks, and fleas. Recent outbreaks of Lyme disease and West Nile virus have given this facility even more importance. By the late 1960s, Fort Collins was attracting a large number of high-technology businesses, moving away from an agricultural focus. (Above, FCM H17872A; below, FCM H17872B.)

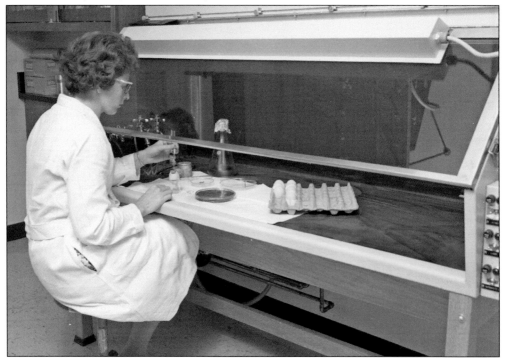

Six

A MILLER PORTRAIT GALLERY

Over the decades of his career, Mark Miller took thousands of photographs, many of them portraits of individual and groups. Some of those he photographed wanted the pictures for personal reasons—weddings, for example, which in those days usually featured only posed pictures of the bride (and occasionally the groom)—or for professional use. Sometimes the portraits were used in advertisements. Before color photography was common, Effie Miller often hand-tinted portraits.

Portraits were the primary way Miller supported his studio and his family. He and his fellow photographers shared the assignment of doing yearbook photographs for the public schools in Fort Collins and nearby communities, and for the college; these images include both individual and group photographs. While the people in the group portraits, though known to those involved at the time, are not often identified in the museum collection, the individual portraits are carefully identified and catalogued.

During the hectic yearbook season, it is not hard to imagine the entire Miller family working day and night to complete the assignments and to provide all those who posed for him a picture they would be pleased with, images that would forever freeze in time the people on the yearbooks' pages and later provide a priceless memento of a special period in their lives. Every member of the Miller family had a job to do to get the pictures ready for on-time delivery.

A lively parade of colorful individuals came through the door of the Miller studio to be photographed. They included many in academic circles or public education as well as mayors, business leaders, innovators, attorneys, and ordinary citizens, some of whom accomplished extraordinary things in their lifetimes. There were so many, their stories so varied, that they could have filled this entire book. However, in order to accommodate the other Miller photographs, the authors have selected what follows—a small sampling of the thousands of individuals photographed by Miller and housed at the Fort Collins Museum.

Dean of home economics at Colorado Agricultural College, Inga Allison discovered that the almost-5,000-foot altitude of Fort Collins affected how baked goods turned out, so she began experimenting with recipes. Lacking a laboratory in which to try them out, she once tried baking on Fall River Road in Rocky Mountain National Park, at over 11,000 feet—with a notable lack of success. By 1927, the college had a high-altitude cooking facility. (FCM M02780.)

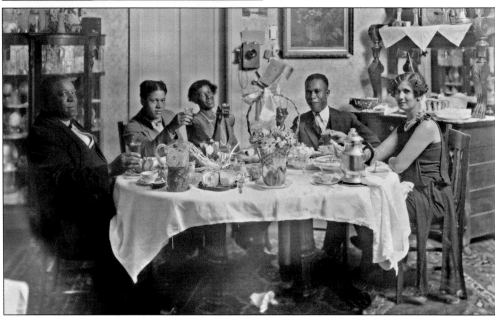

This portrait of the Charlie Birdwhistle family affords a glimpse into a rarity in Fort Collins at that time, an African American home. A veteran of the Spanish-American War, Birdwhistle gained local fame when he waited on Franklin Delano Roosevelt during a luncheon at the Northern Hotel in 1920. When he died in April 1946, Birdwhistle clutched keys to downtown buildings, where he worked as a janitor. (FCM M00350.)

Before T. R. "Ted" Blevins became a loved and respected teacher and coach at Fort Collins High School, he was a World War I sergeant whose gallantry in battle earned him a Silver Star. Blevins introduced basketball to the high school and continued refereeing even after retirement. Following the Poudre School District's traditional way of honoring outstanding educators, Blevins Junior High School is named for him. (WCS.)

A member of Maj. Claire Chenault's Flying Tigers (the aviators who bombed Tokyo in 1942), Bert Christman died doing what he loved—flying. Christman, a 1936 college graduate, drew the comic strip *Scorchy Smith*, featuring a daring aviator and carried in hundreds of newspapers. Learning to fly after he started drawing the strip in the late 1930s, Christman was shot while parachuting from his damaged airplane in Burma. (FCM M03260.)

Digging in an area northwest of Fort Collins in the 1920s, geologist Roy Coffin and colleagues came across some curious artifacts. They turned out to be remnants of a Folsom tribal settlement, which had been there about 12,000 years before. The Smithsonian later sponsored an excavation at the Lindenmeier site; today, though no excavation is taking place, it is part of the city's Soapstone natural area. (WCS.)

After Pearl Harbor, Dr. Philip G. Koontz, a physics professor at the college, joined a University of Chicago team led by Enrico Fermi. On December 2, 1942, this team achieved the first sustained fission chain reaction. The nuclear age was announced to Washington, D.C., with the cryptic message: "The Italian steersman just moored in the New World." Eventually, almost 30 local people worked on the Manhattan Project. (FCM M09316.)

The Fort Collins cultural scene would have been greatly diminished without Editha Leonard, a graduate of the Chicago Music School, who played in the Denver Symphony Orchestra and helped organize and conducted the Fort Collins Concert Orchestra. She later became concert mistress, then business manager, of the Fort Collins Symphony Orchestra under maestro Will Schwartz. Many a local resident mastered an instrument at the Leonard Music Studios. (FCM H21153.)

"Hang your wagon on a star," said Jovita Vallecillo Lobato. "Otherwise, you might not get anywhere." The first Hispanic in Fort Collins to graduate from the high school, she earned a degree from the college in 1936 as the first Hispanic graduate, paying for her tuition by cooking at the Northern Hotel. Her education led her into a long, successful teaching career. (FCM M08253.)

A popular teacher of Spanish at Fort Collins High School for years, William Lopez went on to become a county commissioner and made considerable strides in improving relations between local Hispanic and Anglo residents. Hispanics have known discrimination in Fort Collins; before the Civil Rights Act and the work of local activists, they were often refused service. Hispanics reacted by creating an insular community. (FCM M16262.)

After his death in 1970, an admirer called Librado ("Lee") Martinez (seated) a "red, white and blue American." Martinez, who served in World War I, lost a son, Alonzo, in World War II. Soft-spoken but determined, he advocated for local Hispanics as a member of the Human Relations Committee. Lee Martinez Park, along the Poudre River near the site of the old fort, is named for him. (FCM M12962.)

By the time she died at the age of 104 in 1982, Fort Collins native Mildred McAnelly had seen and experienced immense changes—from horse-drawn transportation to jet airplanes, for one. Born Mildred Goldsborough in the 1870s, she taught school until she married Emmet McAnelly, then started teaching again after her husband's death in 1927 and stayed in classrooms for nearly 30 years. The McAnelly home at 610 West Mountain Avenue still stands. (WCS.)

F. W. "Bill" Michael, who owned a local car dealership, was an outstanding community leader. In the 1950s, he led the drive to create an independent tax-supported hospital district to replace Larimer County Hospital. Poudre Valley Hospital was created under his leadership. A World War II veteran, Michael came to Fort Collins to attend college and stayed to settle here. (FCM M32052.)

An early-20th-century artist for the experiment station who illustrated scientific papers, Miriam Palmer became fascinated with aphids, so much so that she became a world-renowned expert and authored two books. Once, while on a steep mountain road, the brakes of her Model T failed, forcing a retreat to flat land and leaving her frustrated about being unable to gather more information on aphids that day. (FCM M01827.)

He came to Fort Collins to attend college and stayed to sell insurance—and climb mountains. "The old man of the mountains," Roy Murchison, was legendary. He scaled all 54 of Colorado's 14,000-plus peaks ("fourteeners"), one of the first 10 recorded climbers to do so, and conquered Long's Peak again in 1961, at age 79. Murchison stood atop his last peak at age 85. Murchison is pictured here with his wife, Blanche. (FCM M32062.)

Fancher Sarchet, a self-taught attorney who passed the Colorado bar without attending law school, tried several murder cases during his career, but a civil case led to Fort Collins's first drive-by shooting in 1927 when Sarchet was shot by a passing motorist and seriously wounded. He lost an eye. Though the perpetrator was caught, Sarchet always believed an oilman whom he had defeated in court was behind the attack. (FCM H10067A.)

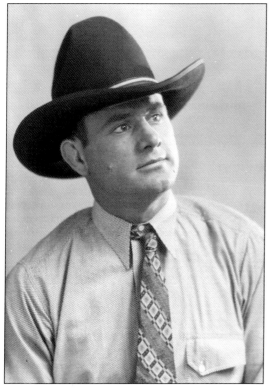

During the Depression, Sheriff Ted Schaffer needed radios for his fleet but lacked funds to get them. Formerly a professional boxer, Schaffer decided to don the gloves and stage a prize fight to earn money for the radios. Outweighing Schaffer by 20 pounds, "Big Bill" Mayfield from Warren Air Base in Cheyenne was astounded to find himself KO'd in the second round. Schaffer got his radios. (FCM M01947.)

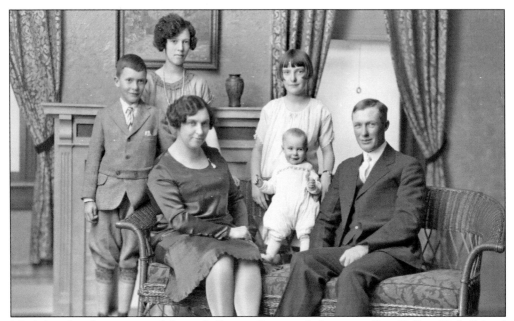

Much loved and very successful, coach George Scott guided teams at Fort Collins High School in the early decades of the 20th century, leading football teams to several championships. His track and field team sought a national championship trophy, which would be theirs if they won it for three years. They captured it in 1927 in Chicago thanks to Dan Beattie's stellar performance on the hammer throw. (FCM M06165.)

Coming to Fort Collins following service in the navy during World War II, Dale Shannon held a law degree from the University of Kansas. He served as a Larimer County prosecutor for more than a decade, then for 22 years as a district judge. After retirement, he became a motivational speaker for John Brown University in Arkansas, working from his Fort Collins home. (FCM M32044.)

One of a corps of women who chose career over marriage in the 1930s and 1940s, Anna Tavelli entertained and inspired fifth-grade students at Remington School throughout her teaching years, often sharing her love of music—honed at the Lamott School of Music in Denver—with her students. The Poudre School District honored this favorite teacher by naming Tavelli Elementary School after her. (FCM M35883.)

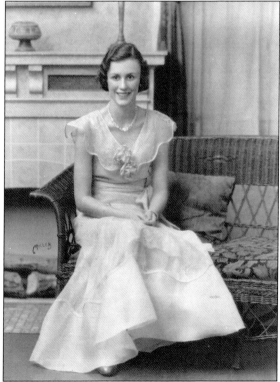

The daughter of a pioneer settler in the Poudre Valley, Martha Trimble joined the WAVES (Women Accepted for Volunteer Service) during World War II, teaching navigation to aviation trainees. She was the first woman in Larimer County to join up. After the war, she began a long career as an English teacher at the college. Trimble Court, a small enclave downtown, bears her family name. (FCM M14462.)

College dramatics were livelier and more enjoyable under the leadership of Ruth Jocelyn Wattles, who came here in 1918. One student described her as "full of life, and fun, and daring." RJ, as she was known, encouraged amateur community theater and directed plays performed in Old Main Theater. A passing train often caused the actors to freeze in place until the sounds faded away. (FCM M30720.)

Early in his career, Miller hired the man in this portrait, whose name is unknown, to pose for him, perhaps intrigued by his unusual appearance. Effie Miller then hand-colored the portrait, which was no doubt intended to advertise their skills. The Miller family donated the portrait to the museum. (FCM.)

Seven

FORT COLLINS AT PLAY

What did the citizens of Fort Collins do in their leisure time? They rode the trolley to City Park, for one. Beginning as a horse racing track in the early part of the 20th century, the park played a central role in recreational activities for Fort Collins folks. In the 1920s, a campground was established there, and the park was expanded.

Picture a summer's day at the park on the west edge of town: children laugh and shout as they romp on the playground. Mothers set out picnics under large shade trees that grace the grounds. Swimmers splash around in the cool waters of Sheldon Lake, sharing the water with fish and water birds. Dogs play together. Put the Miller family in the frame along with many other families, all frolicking and enjoying the park. Miller, of course, has his camera ready.

Or create another picture at Lindenmeier Lake, north of town, where the trolley also took residents to enjoy a day of boating, swimming, fishing, picnicking, or even dancing on the pavilion. The resort also featured ice cream and a small zoo.

People found myriad other ways to amuse themselves—holding all sorts of contests, playing games, putting on dramatic performances, and engaging in imaginative play. With limited funds, the Miller family usually made their own entertainment. Sometimes they took part in local theatrics, too.

Sports were, of course, another popular source of entertainment. In the early part of the 20th century, wrestling and boxing enjoyed widespread popularity, often drawing large crowds at open matches. Neither sport was regulated in those early days. Baseball was ever popular, and football gained in popularity over the decades. In fact, some nationally recognized football players hailed from Fort Collins.

Then there were always parades. Give people an occasion and they would drum up a parade. Sometimes they had parades without a special occasion to celebrate. But always the town turned out to see their friends and neighbors atop a float, riding a horse, or marching along in a band.

Mostly, the pleasures were homespun—and, to judge from the Miller photographs that tell us of that time, enjoyable for all.

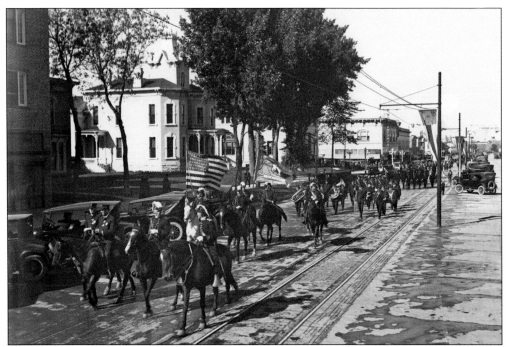

Fort Collins loved parades. This photograph was probably taken at the Fourth of July Parade in 1911, when Miller was working for Claude Patrick. The horses and riders are moving south on College Avenue and have just passed the old post office and the Hottel House, which is now gone. Notice the 46-star American flag, flown between 1908 and 1912. (FCM H02743.)

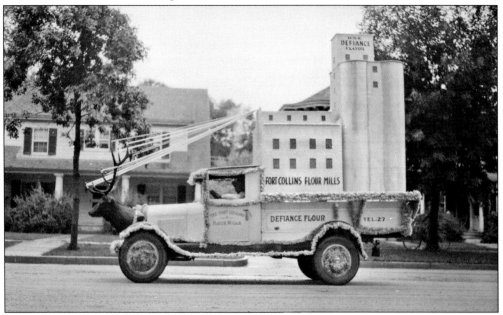

It was September 1948. Elks Lodge No. 804 and all of Fort Collins were hosting the 45th annual convention of the Colorado Elks. Of course, this meant a parade. Fort Collins Flour Mill, sponsor of this float, was located at the corner of Willow Street and Lincoln Avenue, a corner that had a flour mill all the way back to 1867. (FCM H09381.)

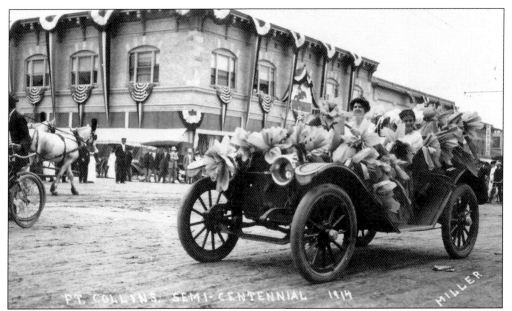

From July 2 to July 4, 1914, Fort Collins celebrated its semi-centennial (50-year) anniversary with the most elaborate program ever seen in the town. Each of the three days started with a different parade, with "floats of merchants, manufacturers, lodges and societies." Pictured here are two examples of the floats. After the parades, celebrants enjoyed free barbecues ("five hundred fat, juicy lambs" one day and "fifty oxen in beef barbeque" the next day), cheered on favorite horses, admired trick-shooting and roping, listened to street concerts, and ended each day with the Irwin Brothers' Wild West Show. The *Fort Collins Weekly Courier* called the celebration a success, estimating that 15,000 people crowded the streets daily. While they were hard pressed to pick the event that pleased the crowd the most, the wild mule race was dubbed a favorite. (Above, FCM H02219; below, MEM.)

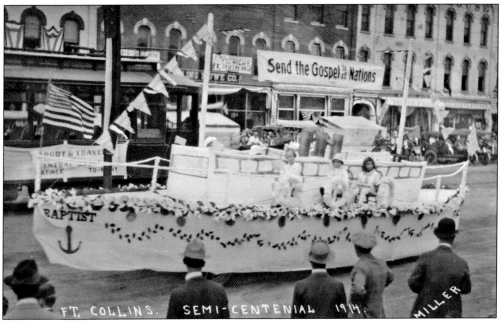

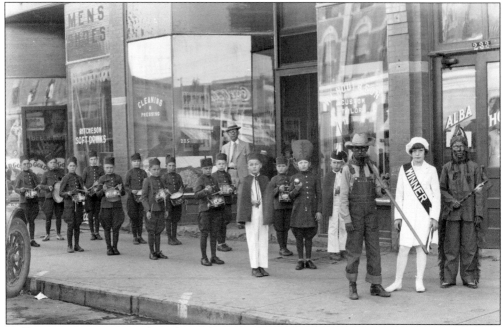

William L. Hout was a tailor whose shop was located at 235 Walnut Street. He apparently sponsored a children's drum band that marched in Fort Collins parades, sometimes carrying a sign advertising his services. Why the three children in front are in costume is lost to history. (FCM H08784C.)

The brief, intense Spanish-American War began in 1898 with the sinking of the battleship *Maine* and ended the same year. More than 100,000 American men fought in Cuba and the Philippines, including future president Theodore Roosevelt and his Rough Riders. These two men, part of the Spanish-American War veterans' drum corps, proudly took part in a parade, probably honoring veterans. (FCM H00880B.)

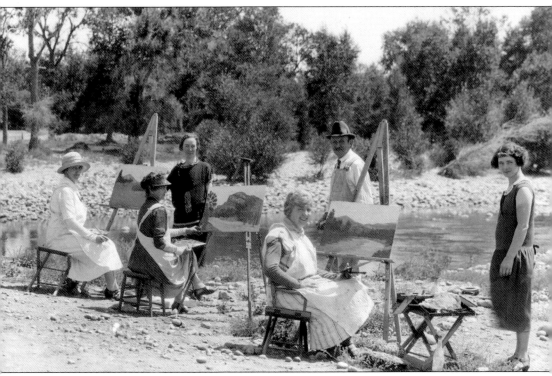

In August 1925, several aspiring artists, including Mark Miller's wife, Effie (standing, left), took part in a class taught by landscape painter Gustaf L. Carlson (standing, center), who was a friend of Western writer Zane Grey. Here the class paints the scenery along the Poudre River near Bellvue, a small town northwest of Fort Collins. (JCM.)

Although no date accompanies this photograph of an etiquette class at Fort Collins High School, it appears the participants took their studies seriously at a time when manners were socially important for success, probably sometime in the 1920s or 1930s judging by the attire. (FCM H18106.)

Before television, before radio, before talking films, there were Chautauquas, which Theodore Roosevelt called "the most American thing in America." These cultural/educational summer events featured orators, performers, and educators offering a variety of public events through a traveling circuit. Chautauquas sometimes came to Fort Collins in the early 20th century; nationwide, three stationary ones survive today. Here Miller depicts an intergenerational group enjoying the fun. (JCM.)

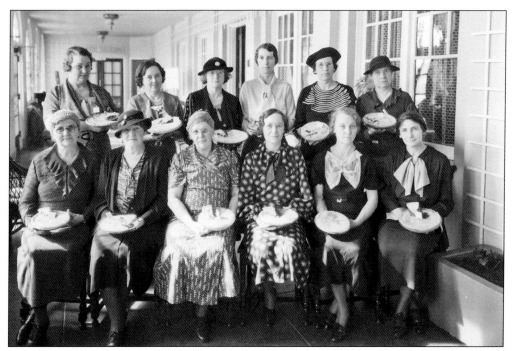

Who baked the best cherry pie? No doubt they were all delicious. The women in this photograph proudly display their pies, all entered in a contest probably held sometime in the 1930s, when domestic arts like baking were highly prized among homemakers. (FCM H17240.)

In 1955, the place to learn how to bake that cherry pie was obviously the cooking classes sponsored by the Busley Super Market, located at 130 West Olive Street. It is not certain where the classes were held, but more than 200 people have showed up to hone their culinary skills. (FCM H17833A.)

"Don't slouch!" "Stand up straight." The authors felt they owed it to mothers everywhere to include this example from a series of almost scientific photographs made for a posture contest, a competition that speaks to the relative innocence of the times. (FCM H09498B.)

Just as television is the focus of American living rooms today, so was the radio in the 1930s and 1940s. Families gathered around the radio listening to favorite programs, news, and music. The beauty shown here is a Majestic Radio (c. 1936) sold by E. E. Polley and Company Radios at 137 West Oak Street. (FCM H17861.)

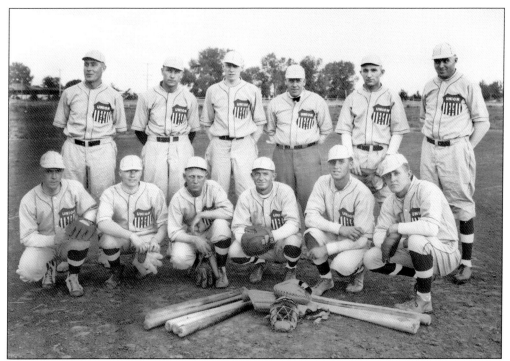

Fort Collins businesses participated in many sports, and Miller photographed a number of sponsored teams. This page shows the baseball team fielded by the Union Oil Company (above) and the bowling team (below) sponsored by Hutchison Drug Company (later Hutchison Rexall), located for years at 100 North College Avenue. (Above, FCM H06208; below, FCM H18221.)

Before it became City Park (1500 West Mulberry Street), the open land west of downtown was Prospect Park, a popular racetrack. When the age of the automobile began in earnest in the 1920s as cars became more affordable, tourists enjoyed going from one scenic area to another, camping en route. This afforded Fort Collins a perfect opportunity to open a campground for travelers. The campground closed in 1940. (MEM.)

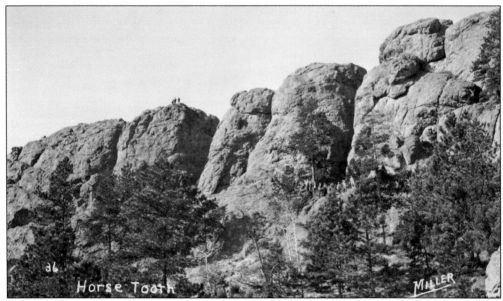

One colorful local legend says that Horsetooth Mountain, which from a distance does indeed resemble a giant horse's tooth, is what remains of the heart of the Great Red Warrior, killed by the Great Black Warrior during a long, fierce battle. Now part of a recreational area west of Fort Collins, it is popular with hikers. (FCM H02679.)

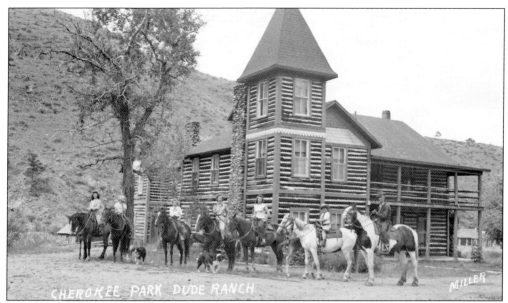

Summer guests returning to Cherokee Park Guest Ranch often said, "It's good to be home again." Bisected by the North Fork of the Poudre River, the Livermore ranch, purchased by Minnie and Herbert Ford in 1949, was a popular getaway. Guests enjoyed square dancing every night, Minnie's home cooking, and an Esther Williams swimming pool, dug by hand. Minnie, who named the difficult wood cook-stove "Leaping Lena," put regular guests' names on clothespins; people would often request the same room every year. Several teepee circles indicated that the site, homesteaded in 1873, was once a Native American campground. The resort is still open, now a popular dude ranch. (Above, FCM H02675A; below, FCM H09853.)

Dressed in their white wigs, long coats, and vests, these small-sized George Washingtons were part of a pageant at the elementary school on Grant Street named for the first president. Will the real George Washington please step forward? (FCM M00018.)

In 1863, Gen. Tom Thumb (born Charles Stratton) and Lavinia Warren, another little person, were married. Circus entrepreneur P. T. Barnum promoted and managed Tom Thumb, making Tom Thumb weddings a popular American fad. During the first half of the 20th century, they were often staged as fund-raisers for schools or churches. (JCM.)

Pedal cars peaked in popularity around the time this photograph was taken, about 1929. This beauty belonged to Sonny Onstad (left), who was willing to share it with his best friend, John Miller (right), Mark Miller's youngest son. Sonny's father, John Onstad, was a foreman at the sugar beet factory. (JCM.)

Sometimes little sisters get to choose what game to play. Here Beth Miller and her brothers Warner (left) and Keith take part in a charming miniature tea party, giving their mother a few moments of respite and giving Beth, who with three brothers described herself as a tomboy, a moment of domestic tranquility. (JCM.)

Dramatic performances put on by school districts and amateur theater groups were often the subject of Miller photographs like this one. Probably a takeoff on the popular Ziegfield Follies, elaborate musical reviews that stormed Broadway from 1907 to 1931, this Fort Collins High School troupe's "AA Follies" must have been somewhat daring at the time. (FCM H18087.)

Informal "clubs" were popular in the early 20th century. This one dubbed themselves the "Silver Lining Club." These young friends visited Miller's studio and were persuaded to pose for him. From left to right are Beth Elaine Miller, Charlene Tresner, Elizabeth Young, and Margery Brood. Years later, when the Miller Collection was donated to the Fort Collins Library, Tresner was the city historian who received the collection. (FCM H18027B.)

Eight

THE POUDRE CANYON PLAYGROUND

When the Miller family piled people, supplies, and camera equipment into their Model A for an excursion up the Poudre Canyon, they unquestionably had plenty of company. On any given weekend, except in forbidding weather, local residents took to the hills—as they still do. The nearby canyon, with its many resorts, tempting fishing spots, and spectacular scenery, has drawn residents and tourists to the area since the first road opened in the early 20th century.

To Mark Miller, it was a photographer's dream landscape.

The Cache la Poudre River acquired its name in the 1840s when (so the legend goes) a group of French trappers caught in a snowstorm "cached," or buried, their "poudre" (powder) by the river bank. A few years later, explorer John Charles Fremont's expedition found the canyon so rugged that they turned back partway through it. Now, though tamed, the canyon still offers challenging hiking trails and thickly forested areas. Part of the canyon is in the Roosevelt National Forest.

Miller loved to fly-fish. The river, placid in some places, rushing in others, is a prime habitat for brown trout. In favored spots along the river, motorists can nearly always spot a fisherman.

For Mark Miller, creating postcards of the Poudre Canyon was more than a money-making venture. He took pictures and turned them into postcards, which have become collectors' items because the scenery was irresistible—the jagged rocks, the clear, bubbling water, the intriguing clouds. It takes only a little imagination to picture the young Miller clan arriving at one of the local resorts with an armful of postcards to replace the ones that had sold, the children eagerly trading their work for an ice cream or a piece of candy. Miller took pictures to capture for himself and for future generations a special place of natural beauty that he and his family deeply cherished, just as the people of Fort Collins do today.

Descendant of Poudre Valley pioneers, native Coloradan Stanley Case and his wife, Lola, bought Arrowhead Lodge in Poudre Canyon after his post–World War II discharge. Case, an electrical engineer, managed the city power plant and served on the American Power Association and Poudre School District boards. His book, *The Poudre: A Photo History*, is a definitive history of Poudre Canyon. No one loved the canyon more. (FCM M32057.)

This trip will begin on the east end of Poudre Canyon at the top of Water Works Hill, about five miles west of the Highway 287–Highway 14 junction, where there was a water treatment plant in Miller's time. Today Gateway Natural Area (milepost 116) offers hiking, picnicking, and an ideal launching point for rafts and kayaks. Look east at the park entrance to see the scene shown here. (FCM H22729.)

Rainbow Ridge rested along a curve in the river known as Rainbow Curve, visible in this photograph. Pete and Mary Townsend operated the store and cabins in the little town of Poudre Park (milepost 112) until the road was rebuilt in 1947 through one edge of the resort, spelling the end of Rainbow Ridge. It was replaced by Pine Vu Lodge. (WCS.)

Pine Vu Lodge at Poudre Park (milepost 112) offered tourists an easily accessible general store and rental cabins. Gordon and Idella McMillan built Pine View (original spelling) Lodge in 1947. On September 24, 1991, the main building burned down. The resort was not reopened, although today tent campers can set up at Columbine Lodge just west of where the Pine Vu Lodge once stood. (WCS.)

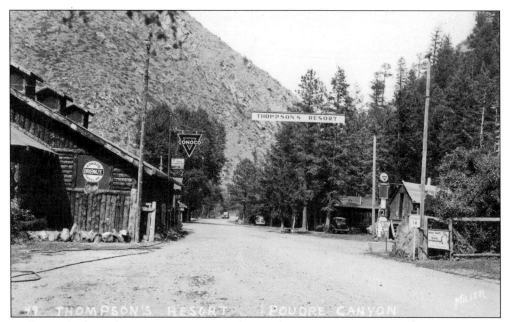

Walker and Alma Thompson, musicians and music lovers, were so charmed by the river's sweet music that they bought land, built a cabin for themselves and rental cabins for income, and opened a store that became a popular community center. Thompson named his riverside paradise Mishawaka (milepost 108), after an Indiana town. Today an amphitheater has replaced the apple orchard. The venue hosts concerts, not square dances. (MEM.)

Convicts, who abided by the honor system throughout construction, built portions of the roads through the canyon and up Pingree Hill to the college research station. The tunnel in the Little Narrows (milepost 107), 14 feet wide and 12 feet high when completed in 1916, allowed the highway to stay close to the river. Cut through solid granite, the Baldwin Tunnel is named for supervisor Charles Baldwin. (MEM.)

On the night of July 31, 1976, a 19-foot wall of water roared through Big Thompson Canyon west of Loveland, Colorado, killing more than 100 people and destroying everything in its path. That same monstrous storm system brought flooding to Poudre Canyon, the water pinching through the Big Narrows (milepost 104), shown here. Bridges were wiped out, and homes were knocked off their foundations. No one died, but damage was extensive. (WCS.)

Ed Trimble was an enterprising fellow, owning, among other things, a rooming house, a restaurant, a store, and a billiard parlor in Fort Collins. He also owned this home in the Poudre Canyon that May Trimble called "the Cottage" in a 1941 note to her daughter, Martha, about this photograph. The bridge shown here spans the river toward Pingree Park (milepost 96). (FCM H14443.)

117

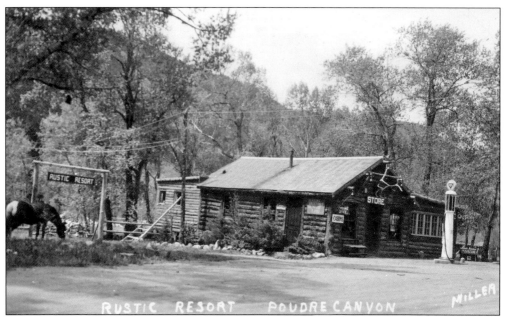

All that is left of Rustic Resort (milepost 91) now are photographs and memories. In June 2008, the store and café burned to the ground. Enduring since the 1890s, beginning as a hotel that expanded into a small community, Rustic was known for its hospitality and charm. In recent years, it enjoyed popularity as a restaurant, a refreshing stop for travelers on their way up the canyon. (MEM.)

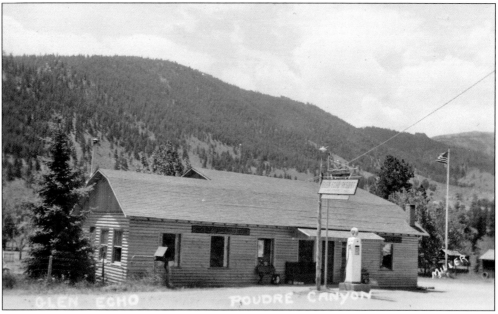

When he arrived in the Poudre Canyon in 1889, Norman Fry, a transplant from England, thought he had landed in heaven. With grit and perseverance, he staked a claim, later opening a small store. Glen Echo (milepost 91) changed owners, locations, and uses several times over the years; when the original building burned down, it was replaced with a store catering to hunters and fishermen. (MEM.)

Although this distinctive rock formation between Rustic and Home, a canyon landmark, is known today as Profile Rock (milepost 89), Stan Case preferred the name bestowed by canyon-dweller Maude Fry: the Old Man of the Poudre. Since the road opened about a century ago, thousands of hikers, bicyclists, white-water rafters, campers, fishermen and women, and motorists have passed under the Old Man's unblinking eyes. (WCS.)

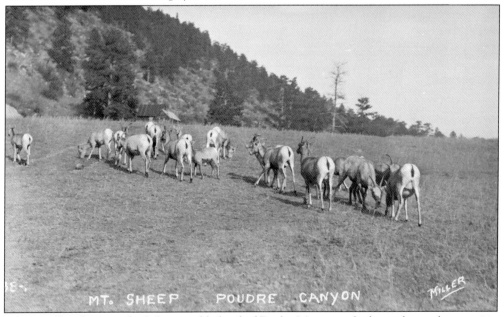

When Miller photographed this sizeable herd of Rocky Mountain bighorn sheep, the parasitic disease that nearly wiped out the state's population had not yet struck. About 30 years ago, a deadly, breath-stealing pneumonia caused major die offs. State wildlife biologists' experimentation led to successful treatment: a drug that, when mixed with fermented apple pulp, proved a gourmet delight to the herds, which have since recovered well. (FCM H08918.)

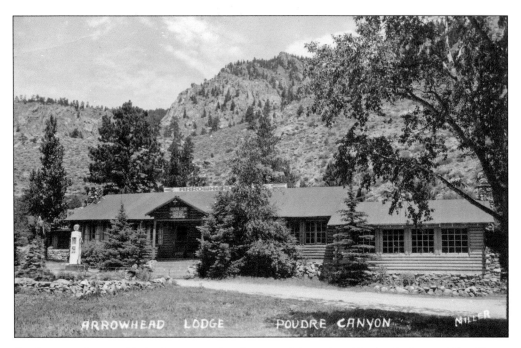

For 39 years, Stan and Lola Case owned and operated Arrowhead Lodge (milepost 88), offering guests a dining room, store, rental cabins, and a cozy room for gatherings. This rustic main room was the scene of many community events—parties, meetings, dinners, dances, and church services. Upon retirement in 1985, the Cases sold the property to the U.S. Forest Service, and in 1993, the resort was saved from demolition by a listing on the National Register of Historic Places. The lodge is open for visitors, with coffee, cookies, and information, and still has the same tile floor shown in the photograph below. (Both, MEM.)

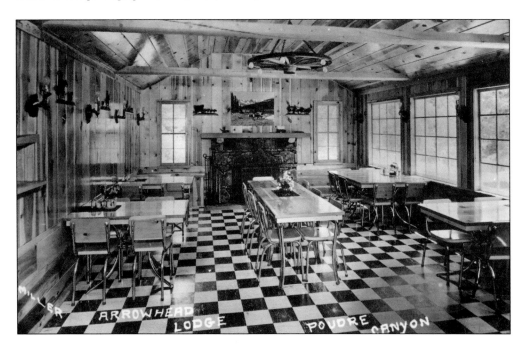

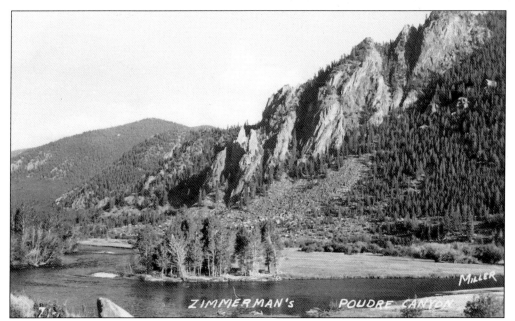

John Zimmerman emigrated from Switzerland to homestead in the Poudre Canyon, where he built the canyon's first resort, the Keystone Hotel, in 1896. A fiddler, he offered visitors music, inspiring scenery, and fine trout fishing. In 1946, surviving daughter Agnes Zimmerman sold the land to the Colorado Game and Fish Department, which razed the resort, leaving only a dilapidated icehouse in front of the Home Moraine Trailer Park (milepost 85). (MEM.)

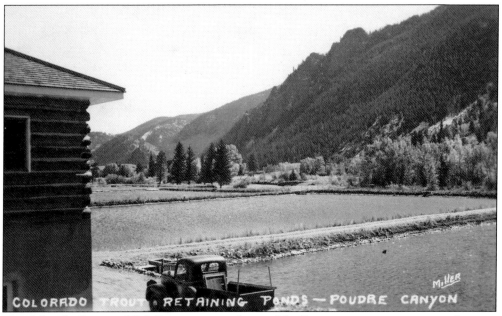

The Colorado Game and Fish Department used part of the Zimmerman property to open the trout rearing unit shown in this photograph (milepost 84). In 2000, whirling disease, a parasitic infection that attacks juvenile trout, was found in the Poudre River. Further testing found significantly higher levels of the parasite in the retaining ponds. The ponds were drained and are still empty, with trout now raised in raceways. (MEM.)

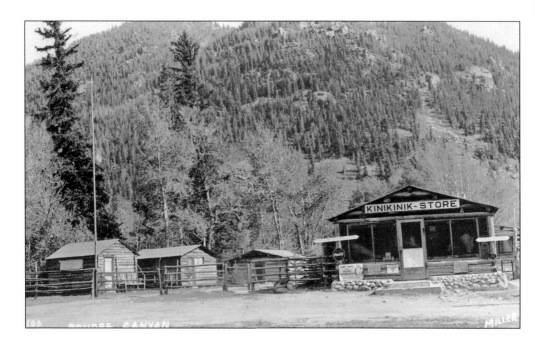

Charles Andrews started Kinikinik Ranch around 1885 to raise Shetland ponies for the British market. The name, which may have come from a Native American word for an indigenous, low, creeping evergreen plant, is one of the longest place-name palindromes in English. Capt. Charles Williams, who served in the Colorado National Guard, took over the ranch in 1901. Because Williams loved fishing and receiving guests more than ranching, he added guest cabins and the Kinikinik Store (milepost 81). The store flourished until the early 1960s but is now closed and deteriorating badly. (Above, WCS; below, FCM H17637.)

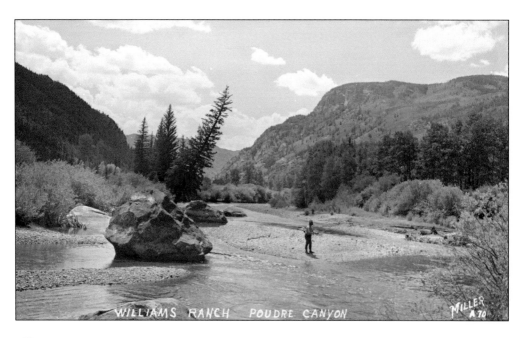

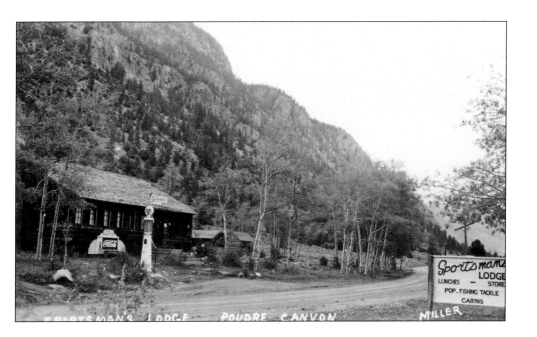

Sportsman's Lodge (milepost 78) opened for business in 1931 on land once part of the Kinikinik Ranch. Sportsman's Lodge began as Gladstone Cottages, featuring cabins and family-style meals. William and Clara Schoeman owned Sportsman's Lodge in the 1940s, adding more cabins converted from one-car garages hauled to the site. Still open today, the lodge features rental cabins and camping sites. (Both, MEM.)

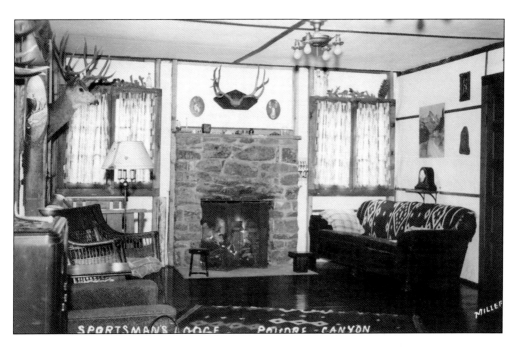

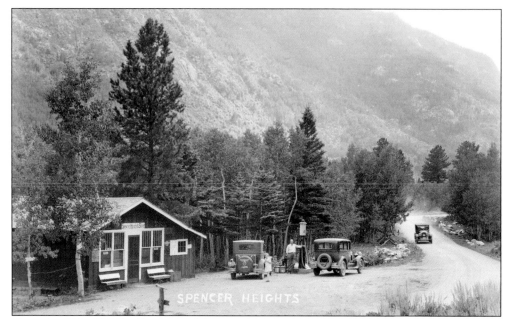

Once the Alfred Willard homestead, Spencer Heights (milepost 78) was platted as a subdivision in 1927. The subdivision never happened, perhaps because of the Depression, although a trailer park was there for a while. Spencer Heights Trading Post was the last stop for food and gas before Cameron Pass. After the U.S. Forest Service took over the property in 1994, they removed most of the evidence of Spenser Heights. Only an asphalt pull-off remains. (FCM M00340.5A.)

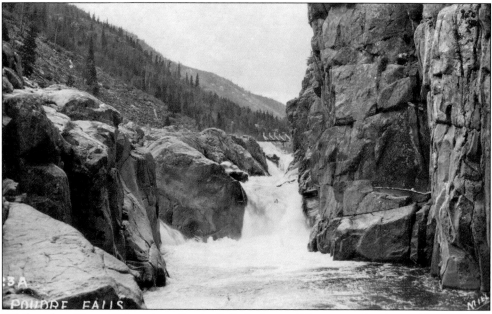

While only a 30- or 40-foot drop, Poudre Falls (milepost 75) presented major problems to early loggers. Logs floated down the river often jammed at the falls. One logger was killed trying to untangle a mess. And the falls and its canyon presented such challenges that the earliest road stayed on higher ground. Twenty years would go by before a road was cut along the falls. (FCM M00023A.)

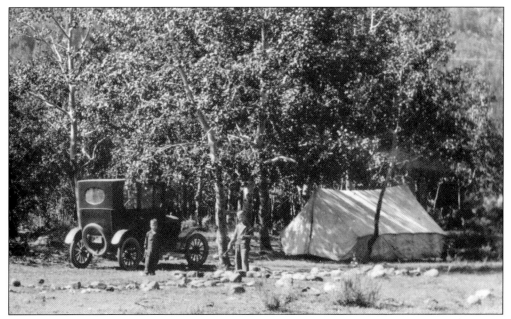

Workers dammed Chambers Lake (milepost 71), a natural lake, more than once—wooden dams gave way, flooding the canyon. A stronger dam was completed early in the 20th century. Here two Miller boys are at the Chambers Lake campgrounds, long a locally favorite spot. When driving up the canyon, overloaded with people and gear, the Millers often had to pile out, turn the car around, and go up a hill in reverse. (JCM.)

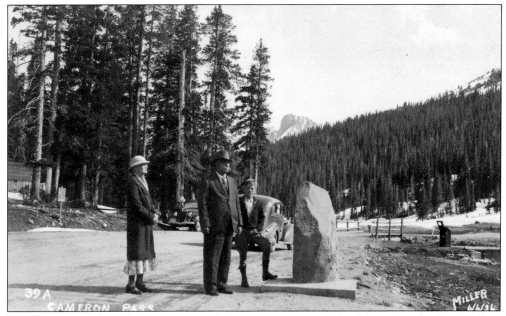

In 1872, Gen. Robert A. Cameron, a Union army veteran, helped organize the Fort Collins Agricultural Colony, which evolved into the city of Fort Collins. On a trip to Chambers Lake, he discovered the pass, later named Cameron Pass (milepost 65) by the Union Pacific Railroad Company. The railroad abandoned its plan to construct a line through the pass to Walden, defeated by the rugged terrain. (MEM.)

It is not known quite where Miller came upon these two male deer, which had been locked in combat and then could not untangle their antlers after they somehow became wrapped in barbed wire. Deer and elk are among the many species of wildlife found in the canyon. In the fall, males compete for mates—sometimes, though rarely, the competition ends badly. (FCM H06198.)

The Millers had a cabin near Indian Meadows (milepost 93) that for years served as their vacation getaway and their base of operations in the Poudre Canyon. During his long career, Miller took hundreds of images of the canyon he loved. We leave Mark Miller here, in this beautiful place, which brought together three things he cherished deeply—his family, fly-fishing, and photography. (JCM.)

Housed in the 1904 Carnegie Library Building, the Fort Collins Museum, including the Fort Collins Local History Archive, is focused on preserving and sharing the cultural and natural heritage of the community. The museum at 200 Mathews Street, in Library Park, offers workshops, exhibitions, lectures, and tours for the community, while the History Archive works with researchers, authors, genealogists, students, and other individuals to locate historical information and photographs relating to Fort Collins and Larimer County. If you have local history questions to ask or collections to donate, contact the Fort Collins History Archive at 970-221-6688 or look online at history. fcgov.com. (Note that this is not a Miller photograph.) (FCM H03572.)

DISCOVER THOUSANDS OF LOCAL HISTORY BOOKS
FEATURING MILLIONS OF VINTAGE IMAGES

Arcadia Publishing, the leading local history publisher in the United States, is committed to making history accessible and meaningful through publishing books that celebrate and preserve the heritage of America's people and places.

Find more books like this at
www.arcadiapublishing.com

Search for your hometown history, your old stomping grounds, and even your favorite sports team.